LEGENDARY LOCALS

OF

ROSWELL

NEW MEXICO

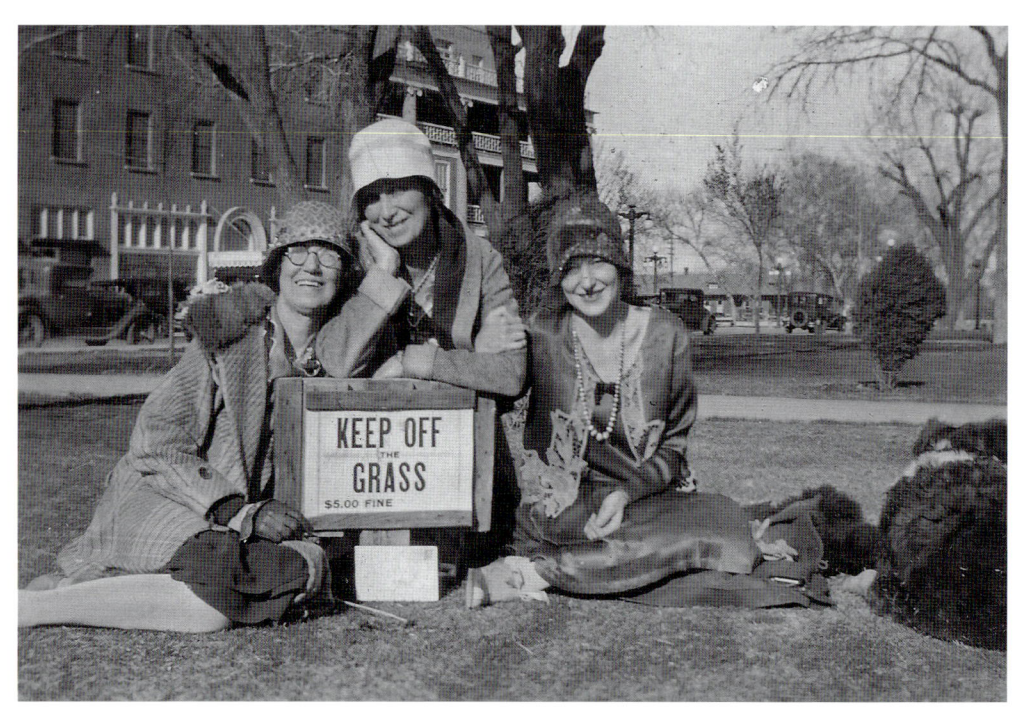

Annie Laurie Snorf

The woman in the middle of this photograph is Annie Laurie Snorf. Although born in Michigan, Snorf became a part of Roswell in 1905 and became, as Elvis Fleming called her, "a bright personality on the Roswell social scene for over six decades." Snorf's main claim to fame was her poem "Out in New Mexico," featured in *New Mexico Magazine* and later put to music by Elizabeth Garrett. Snorf died at 92 in 1967 in Roswell where she is still fondly remembered.

PAGE 1: See page 33

LEGENDARY LOCALS

OF

ROSWELL

NEW MEXICO

JOHN LEMAY and
ROGER K. BURNETT

LEGENDARY
LOCALS

Published by Legendary Locals, an imprint of Arcadia Publishing
Charleston, South Carolina

Printed in the United States of America

Library of Congress Control Number: 2011944032

For all general information, please contact Arcadia Publishing:
Telephone 843-853-2070
Fax 843-853-0044
E-mail sales@arcadiapublishing.com
For customer service and orders:
Toll-Free 1-888-313-2665

Visit us on the Internet at www.arcadiapublishing.com

Dedication
To all the people we forgot to include.

On the Cover: From left to right:
(TOP ROW) Pat Garrett, lawman (Courtesy of University of Texas at El Paso, Special Collections Department; see page 18), Nancy Lopez, pro golfer (see page 83), Dr. Robert H. Goddard, father of modern rocketry (NASA photograph Courtesy Roswell Museum and Art Center; see page 54), Uncle Kit Carson, Wild West show performer (see page 67), Elizabeth Garrett, singer/songwriter (see page 50).
(MIDDLE ROW) Amelia Bolton Church, philanthropist (see page 94), Lake Frazier, mayor (see page 105), Maj. Jesse Marcel, intelligence officer 509th Bomb Group (Courtesy *Fort Worth Star-Telegram* Collection, Special Collections, the University of Texas at Arlington; see page 118), Elvis E. Fleming, historian (see page 86), Edgar Mitchell, Apollo 14 astronaut (Courtesy NASA, see page 120).
(BOTTOM ROW) Morgan Nelson, philanthropist (see page 103), Sam Donaldson, news anchor (see page 104), Peter Hurd, painter (see page 60), Sage, search and rescue dog (Mark Wilson photograph, see page 124), Robert O. Anderson, philanthropist (see page 100). All uncredited images in this book courtesy the Historical Society for Southeast New Mexico.

CONTENTS

ACKNOWLEDGMENTS

For their help in gathering photographs and information on the people in this book, we thank UFO researcher Noe Torres, photographer Mark Wilson, Reverend Landjur and Astuti Abukusumo, Janet Jaquess, who is related to not one, but two of the "superstars" in this book, Kate Ediger and Kay Srader in Tim Jennings' office, Donna Oracion at ENMU-R, Jolene and Frank Lilley, Michael Lutz at 21C Media Group, Inc., Morgan Nelson, and Elvis Fleming. Elvis not only proofread the text (like he generously does with all of our books), but also managed to help us find some great photographs that would have otherwise been lost to us. In that vein, we also thank Ken Case, who unknowingly helped us by finding the last missing piece of our puzzle: a photograph of Demi Moore tucked away in an old NMMI yearbook. Thanks Ken! And also a big thanks to our editor, Tiffany Frary, who was always patient and quick to respond to our questions.

All of the photographs in this book, unless noted otherwise, are courtesy of the Archives for the Historical Society for Southeast New Mexico in Roswell.

INTRODUCTION

Two of the most popular legends of New Mexico are arguably that of outlaw Billy the Kid and the alleged Roswell Incident UFO crash. Both have spawned major motion pictures, books, novels, and even comic books. What most people don't know is that both of these legends have roots in Southeast New Mexico near Roswell, not just the downed UFO. Lincoln, the town where Billy the Kid attained his legendary status, is only 40 miles from Roswell and the Kid often visited the town, despite warnings from Roswell patriarch Capt. Joseph C. Lea to keep out.

As recently as 2011, the Kid was used in a statewide "scavenger hunt" called Catch the Kid, a huge tourism promotion for the state of New Mexico. The promotion encouraged New Mexico residents and tourists alike to "hit the road" and traverse the same locations as the Kid looking for clues as to the Kid's whereabouts as though he were still alive and well. Ironically, Pat Garrett, the sheriff who killed Billy the Kid at 21, was himself killed by a 21-year-old man by the name of Jesse Wayne Brazel. Brazel was the second cousin (or uncle depending upon which account one goes by) of William Ware "Mack" Brazel, who later found strange debris on his ranch in 1947 and brought samples of it to Roswell. The town was never the same after many speculated Brazel's debris came from a spaceship. How fitting that New Mexico's two greatest legends have a family tie.

As for the Roswell Incident, although it occurred in 1947, it didn't become common worldwide knowledge until 1997. On the much-discussed event's 50th anniversary in July, Roswell got tons of coverage, even landing the cover of *Time* magazine, which did a large story on Roswell's UFO Festival. Though this wasn't Roswell's first UFO Festival, it was the biggest, with 40,000 tourists and media personnel touring the town in search of little gray men. This was the year that everyone in the world learned of Roswell and its aliens. A Roswell resident could talk to someone as far away as Germany and they would inevitably be asked about "the aliens." Real or not, the aliens seem to be Roswell's most famed residents. However, Roswell has also been home to many earth-bound celebrities who far outnumber the four dead aliens.

Among Roswell's famous citizens were lawman Pat Garrett, who lived here with his wife and many children. One of the children, Elizabeth Garrett, would grow up to write New Mexico's state song, "O Fair New Mexico." In the 1970s, John Wayne starred in one of his more popular westerns: *Chisum*. Though Roswell is hardly mentioned in the film, Roswell was the headquarters of the real cattle baron John Chisum, the model for Wayne's hero, in the 1800s. George Causey, the famous buffalo hunter, spent his final days near Roswell and is buried here, though only recently did he get a formal marker at his grave thanks to the Historical Society for Southeast New Mexico. An unsung hero of the late 1800s is Roswell patriarch Capt. Joseph C. Lea, a well-known man across the Southwest in his day (and far more influential than his comrades who still appear as historical characters in films), but often forgotten today.

Roswell is also the home to many exceptional athletes. One of the most famous players in the LPGA, Nancy Lopez, lived in Roswell and has an elementary school here named for her. Before Barry Bonds broke the world record for home runs in one season, the record was held by a minor league baseball player in Roswell, the great Joe Bauman, who hit 72 home runs in a season in 1952. Tom Brookshier, who at first played for the Eagles in the NFL, later became a famous sportscaster and sports commentator for CBS. His hometown was Roswell. Before he became quarterback of the Dallas Cowboys from 1969 to 1979, Roger Staubach played football for the Broncos in Roswell—the New

Mexico Military Institute's Broncos that is, in the 1960s during his college days. Speaking of NMMI, many celebrities and entrepreneurs have briefly lived in Roswell thanks to the esteemed military school. Among them surprisingly are popular comedy star Owen Wilson, and before him hotel magnate Conrad Hilton, news anchor Sam Donaldson, Pulitzer Prize winner Paul Horgan, and esteemed painter Peter Hurd.

The fact that actress Demi Moore was born and raised in Roswell is common knowledge. Most people are unaware, however, that Roswell is also the birthplace of singer/songwriter John Denver, as well as modern-day opera star Susan Graham. Roy Rogers, truly a mega-star in his day, often played music in Roswell before he became famous and met his first wife here. Old-time movie star Joel McCrea lived on a ranch in the Roswell area with his equally famous wife, actress Frances Dee. In an interesting coincidence, Joel McCrea starred in a film based upon a story written by a Western writer, Eugene Manlove Rhoads, who briefly lived in Roswell.

While actors and musicians get a lot of attention, one of Roswell's most important residents was neither, but his work had far-reaching effects—all the way to the moon to be exact. Robert H. Goddard moved to Roswell in the 1930s to conduct experiments in rocketry due to the area's seclusion. His rocket tests back home in Massachusetts were a bit too unsettling for the easterners.

In Roswell also resided many beloved local celebrities, such as weatherman "Cactus Jack" John Anderson; eccentric circus performer Uncle Kit Carson; Mine That Bird, a former Kentucky Derby winner; Sage the service dog, a September 11th search and rescue survivor; Orville Kisselburg, the "Daredevil Clown" who befriended Evel Knievel; Alejo Herrera, the "Methuselah of Chihuahuita" who lived to be 117; and many other interesting Roswellians.

Yes, the aliens may be Roswell's most famous residents for now, but in the pages ahead will be told the story of Roswell's real heroes and "superstars."

CHAPTER ONE

Western Giants: Cattle Barons, Lawmen, Gunslingers, and Outlaws

Today Roswell is a medium-sized relatively calm community of around 50,000 people, a place where many retirees like to move because of its semi-small-town status and year-round agreeable climate. But things were not always this way. Once Roswell was a gamblers' haven in the violent and turbulent county of Lincoln in New Mexico Territory, during what is now known as the Lincoln County War in the 1870s. The so-called war was fought between wealthy landowners (among them Lawrence G. Murphy of Lincoln) and their hired hands (backed by John S. Chisum of Roswell).

Most of the shootouts and killings occurred in the nearby village of Lincoln, about 40 miles west of Roswell, but occasionally the violence spread to other towns in the vicinity, including Roswell. The town began as a small trading post in the early 1870s, and under the influence of its master Van C. Smith, who had a penchant for gambling, the small hamlet was typically astir with all-night poker games, dog and cock fights, and even horse racing. Eventually, Smith grew restless and left the town, which was soon taken over by Capt. Joseph C. Lea, a Civil War veteran. But even though the gamblers were gone, Captain Lea would still have his hands full as occasionally outlaws like Billy the Kid used to ride through town.

Van C. Smith

"Van C. Smith is a gambler of what is called the superior class," wrote Smith's friend and employee Ash Upson. "That is, he is looked upon as an honorable man," continues Upson, "who can step into the store of a merchant and borrow a few hundreds whenever he chooses; if he is dealing faro and a greenhorn bets on his game, Van will tell him honestly when he wins or loses—in short he will not cheat at his game." Smith, the Wild West gambler, who was born Van Ness Cummings Smith in Ludlow, Vermont, in 1837, came upon the future site of Roswell in 1868 when it consisted of only a 15-by-15-foot adobe trading post built by James Patterson along the Goodnight-Loving Cattle Trail. Smith saw potential to cultivate the area, bought the land from Patterson, and soon added onto the structure turning it into an all-in-one saloon, casino, restaurant, and hotel. Smith didn't stop there and also built a general store next door that also served as a post office. When it came to naming his small hamlet, Smith named it after his father, Roswell Smith, of Nebraska, in 1872. Thanks to Smith, Roswell was a somewhat notorious gamblers' haven and the scene of all-night card games, cock and dog fights, and even horse races. Smith eventually grew tired of his small hamlet and left Roswell to start a casino in Santa Fe. Smith was also one of the founders of Prescott, Arizona, as well as being the first man to hold the office of sheriff in Arizona in 1864. Smith also served as an Indian scout, a deputy sheriff, and even a prospector in Old Mexico in his later years. He died in Prescott in 1914 and is buried in the Arizona Pioneers Home there. (Drawing by K. Gunnor Peterson, courtesy Stu Pritchard.)

James Patterson's Trading Post

Patterson, who built the first structure in Roswell later acquired by Van Smith above, is often neglected in Roswell history. He was a beef contractor during the Civil War and was once called New Mexico's largest cattle dealer by a newspaper of the time. Patterson was killed in a gunfight with a disgruntled miner (an employee of Patterson's) near Silver City, New Mexico, in 1892.

Ash Upson

In his work *The Bitter River*, author Tom Sheridan refers to Ash Upson as the "quintessential drunken western journalist." Upson served as Roswell's second postmaster in the general store built by Van Smith, where he occasionally indulged in various libations. Upson was also once the houseguest of Billy the Kid and his mother in Silver City, New Mexico. Later, Upson would ghost-write Pat Garrett's *An Authentic Life of Billy the Kid*.

John Chisum aka Cattle King of the Pecos

Chisum was born in Tennessee on August 15, 1824. At the age of 13, he moved to Paris, Texas, with his family. After working as a building contractor and county clerk, Chisum got involved in the cattle business. In 1854 he started to work cattle in North Texas. He established the settlement of Bolivar and from there drove many herds to the South as a beef supplier to the Confederacy. Later, he moved his operations to Southeast New Mexico in the Bosque Grande area north of present-day Roswell. Chisum is better known for his South Spring River Ranch southeast of Roswell, which he moved to during the 1870s. He became one of the largest cattlemen in the United States with over 100,000 head of cattle. Chisum formed a partnership with cattlemen Charles Goodnight and Oliver Loving to assemble and drive herds of cattle for sale to the Army in Fort Sumner and Santa Fe, New Mexico, and to provide cattle to miners in Colorado. One possibly apocryphal story about Chisum's time in New Mexico involves him raiding the Indian encampment at Fort Stanton. Yes, that's right, Ft. Stanton was an army fort. Supposedly Chisum was thoroughly fed up with the Mescalero Apaches raiding his land, so he followed them back to Fort Stanton. There he supplied the military officers with enough liquor to get them falling down drunk, after which he and his men proceeded to raid the Indian village! Chisum was also involved in the Lincoln County War, mostly in the background by financing John Tunstall and Alexander McSween's efforts to thwart Lawrence G. Murphy, somewhat of a tyrant in Lincoln County. Chisum's ranch sometimes served as a place of refuge and sustenance for the Regulators. The known outlaw, Billy the Kid, would often come by and stay at Chisum's Jingle Bob Ranch. Chisum died of a large tumor on his neck in Eureka Springs, Arkansas, on December 23, 1884, and was buried in the family plot in Paris, Texas.

John Chisum and Old Ruidoso

On March 24, 2001, a bronze statue of John Chisum built by Robert Temple Summers was erected on Pioneer Plaza in Roswell directly across from the courthouse. The photograph above shows the statue dedication, in which historian Elvis E. Fleming portrayed Chisum, complete with his signature handlebar mustache. Old Ruidoso, the long-horned steer sculpted alongside Chisum, has a legend rivaling that of his master. The story goes that Old Ruidoso was cursed with a skull and crossbones brand that made him bad luck. The train carrying him to slaughter derailed and he escaped to the mountains, where his bellowing ghost frightened travelers for several years. Rumor has it he was seen in the mountains as an omen the night before Albert Jennings Fountain disappeared in White Sands, never to be seen again.

Sallie Chisum Robert

Sallie Lucy Chisum was born in May of 1858. Her father was James Chisum, the brother of the famous cattleman John Chisum. In 1877, she moved to New Mexico to live with her Uncle John at his South Spring Ranch. Sallie soon met Billy the Kid, and they became fast friends who rode and raced horses together and visited on the porch swing at night for hours on end. It has been said that she was wooed by every cowboy in Lincoln County. She was married to William Robert in 1880. One of the first artesian wells was eventually drilled on Sallie's land, changing farming and ranching in the area forever. She later became a very successful cattlewoman, much like Susan McSween. She died in 1934 and is buried in Roswell. A statue in her honor was erected in Artesia, New Mexico.

Frank Chisum

Frank Chisum, pictured above and below, was born Benjamin Franklin Daley in 1855 and received his surname from his master, John Chisum. Though stories differ on how the two met, the more accepted story is that a "scalawag" attempted to trade young Frank to Chisum for a horse. Chisum accepted the offer to get four-year-old Frank away from his cruel master and from then on treated him as a stepson. Frank grew into one of Chisum's better cowhands at South Springs. After John's death, Frank became one of the wealthiest African American cattle owners in the Territory, if not *the* wealthiest. Frank lived in Roswell and was married twice over the course of his life. He died in Wichita Falls, Texas, in 1929, and is buried in the Lakeview Cemetery there.

Charles Goodnight

Charles Goodnight was perhaps the best-known cattle rancher in Texas. He has been referred to as the "father of the Texas Panhandle." Goodnight was born just east of St. Louis, Missouri, and moved to Texas in 1846 with his mother and stepfather, Hiram Daugherty. A cowboy at first, then a Texas Ranger, Goodnight led a posse against the Comanche in 1860 that located the Indian camp of Cynthia Ann Parker. He was later responsible for the treaty with her son, Quanah Parker. He fought for the Confederate States of America during the Civil War. After the war, he started herding feral Texas Longhorn cattle northward from West Texas to railroads. In 1866, he partnered with Oliver Loving and drove the first herd of cattle northward along what would become known as the Goodnight-Loving trail. Goodnight later formed a partnership with John Chisum to supply the US Army with cattle. Goodnight's other accomplishments include inventing the chuck wagon, creating the first Texas Panhandle ranch in 1876, founding the Panhandle Stockman's Association, preserving a herd of native bison, and crossbreeding buffalo with domestic cattle, which he called cattalo.

Alejo Herrera

The first widely inhabited area of Roswell was a small Mexican village called Chihuahuita, or little Chihuahua. Today the Chihuahuita neighborhood is still part of Roswell, and in 1936 the man above, Alejo Herrera, was known as the "Methuselah of Chihuahuita" due to his advanced years. Herrera was born in Mexico in 1819 and was captured by Apaches at age 11. He lived with them until he escaped with a captive white girl during a drunken brawl at the camp in 1849. In the 1870s, Herrera was said to have been a brave fighter in the Lincoln County War and hid outlaw Billy the Kid from the law on two separate occasions, once in his bedroll. In his later years, Herrera lived in Chihuahuita under the care of his good friends Augustin and Lola Garcia. He passed away of extreme old age at 117 in 1936.

Sheriff Patrick Floyd Garrett

Pat Garrett was one of the most noted frontier sheriffs of New Mexico, famous mainly for killing Billy the Kid at Fort Sumner in July of 1881. Born in Chambers County, Alabama, he became a cowboy in Texas from 1869 to 1875 and a buffalo hunter from 1875 to 1878 before landing in Fort Sumner, New Mexico Territory, where he opened up his own saloon. Some people claim that while in Fort Sumner he befriended Billy the Kid, but whether the two men were friends or merely acquaintances is still hotly debated. Lincoln County officials eventually persuaded Garrett to become the county sheriff and rid the county of Billy the Kid and other cattle rustlers. He was elected sheriff in 1880 and became the acting sheriff even before his term officially began. Principal events included the capture of Billy and his gang at Stinking Springs, escorting the Kid to La Mesilla for trial and then back to Lincoln to be hanged, hunting the Kid down after he escaped, and shooting him to death at Pete Maxwell's house at old Fort Sumner on July 14, 1881. After retiring from law enforcement in Lincoln, he became a cattleman and businessman, owning many rental houses in Roswell. Garrett called Roswell his home for eight years with his wife Apolinaria, who would eventually bear him nine children in all. Garrett conceived the idea of building irrigation canals in the Pecos Valley. J.J. Hagerman and Charles B. Eddy, who brought the plan to a successful implementation, pushed Garrett out of the project after he had spent all his money. He ran for sheriff of the newly formed Chaves County. After being defeated in the polls and upset with the citizens of Roswell for not electing him, he moved to Uvalde, Texas, in 1891. He returned to New Mexico in 1896 to investigate the disappearance of Albert Jennings Fountain and Fountain's young son, Henry. (Courtesy of University of Texas at El Paso, Special Collections Department.)

Front View of Home

Garrett's Pistol and Home

Pat Garrett held various positions over the years, including that of sheriff of Dona Ana County, 1896–1900, and then, in 1901, as the customs collector at El Paso, Texas. He lived out his life at his ranch in the Organ Mountains near Las Cruces, New Mexico. He was shot to death on the trail near his ranch during an argument over his land and its usage. Several men were suspected of the murder, among them an Old West assassin named Killer Jim Miller and another man named Jesse Wayne Brazel, but nobody was ever convicted of the crime. Pictured above is Garrett's gun, and below is his Roswell home.

19

William H. Bonney aka Billy the Kid

Many books and films based upon the legend of Billy the Kid have been made. Some like 1988's *Young Guns* stick fairly close to the truth, while others such as *Billy the Kid vs. Dracula* are pure fiction. Most of Billy the Kid's early years are shrouded in mystery, but most historians concur he was born William Henry McCarty in November of 1859 to Catherine and Michael McCarty. Where exactly is uncertain, but New York remains a popular conjecture. It was in 1877 that Billy (under the alias William Bonney) was working in Lincoln County in the employ of Englishman John Tunstall, whose murder sparked the Lincoln County War. After the death of his boss, Billy became a vigilante avenger along with several other men called The Regulators. It was during his time as a Regulator that Billy did most of his killing. Some argue it was justified and others do not, but in any case it is doubtful he killed 21 men, one for each year of his life, as it is said according to legend. Rumor has it that after the killing of Sheriff Brady, Billy and his gang hid out near Roswell by Bottomless Lakes. Actually, some believe it was Billy and his friends who dipped their lariats into the heretofore unnamed lakes and christened them Bottomless Lakes, though this has never been confirmed. Billy traversed through Roswell fairly often, usually to go to the South Spring River Ranch and see Sallie Chisum. Though an outlaw, Billy did keep his word. During the Lincoln County War, Capt. Joseph Lea of Roswell sent for the Kid to have a talk with him about his wild ways. Lea said to Billy, "Bonney, if I ever catch you here in Roswell cutting up any of your capers, I'll take my Winchester and fill you full of holes." Bonney replied, "All right, Cap'in. I promise I won't ever cut up any capers in your Roswell." The Kid never caused any troubles in Roswell, and it would be Garrett that would eventually "fill him full of holes."

BILLY THE KID WAS KILLED BY SHERIFF PAT GARRETT ON JULY 15TH, 1881 AT FORT SUMNER, N.M.

Pat Garrett and Billy the Kid

Two actors pose as Pat Garrett and Billy the Kid in the postcard at the bottom of the page. Some speculate that Garrett and the Kid were gambling buddies who nicknamed each other "Big Casino" and "Little Casino." What is for certain is that Garrett shot and killed the Kid in a darkened room in Fort Sumner in July of 1881. The duo's complicated relationship is probably best explored in Sam Peckinpah's controversial western *Pat Garrett and Billy the Kid* in which James Coburn portrays an aging Garrett and Kris Kristofferson the Kid. Only one legitimate photograph of the Kid exists, and the picture at the top of this page is another unproven image of him.

Capt. Jason W. James
James was a Confederate artillery commander during the Civil War, usually serving under Capt. Joseph Lea. He moved to Roswell with his wife and three nieces in 1892. James had a huge influence on NMMI, providing rifles and ammo to the school for target practice on a regular basis. Later, Jason W. James Rifle Medals were awarded to students who excelled in marksmanship.

Eugene Manlove Rhoads

Eugene Manlove Rhoads was a famous writer of the Old West who in 1905 briefly served as editor on the *Roswell Daily Record*. Rhoads's popular stories were serialized in magazines of the time. His most famous work, *Paso Por Aqui*, was later made into a film, *Four Faces West*, ironically starring Roswell rancher and movie star Joel McCrea.

Charles Siringo aka The Cowboy Detective

Siringo was part of the famous Pinkerton Detective Agency. His cases took him as far north as Alaska and as far south as Mexico City where he would infiltrate dangerous gangs of thieves and robbers and bring them to justice. Siringo stayed overnight at the Adams house near Roswell one night when a baby was born and named Clarence Siringo Adams. That child grew up to become one of Roswell's more famous historians. (Courtesy the N.H. Rose Collection.)

"Cap." Burt Mossman

Mossman was born in 1867 and came to New Mexico in 1882. He led an adventuresome life, serving in the Arizona Rangers. Mossman captured and arrested one of the most bloodthirsty killers in all of Arizona at the time: Augustin Chacon. Chacon had stolen and then driven many cattle from Arizona into Mexico and his roving band may have killed as many as 25 people in the territory. Mossman so wanted to capture the bandit, he rode into Mexico violating international law. Mossman did capture Chacon, who was executed in Arizona in 1902. In his later years in Roswell, on one occasion Mossman arrested two armed men hunting illegally on his land, even though Mossman himself was unarmed! Mossman lived in Roswell for a time and also owned the famous Diamond A Ranch in Lincoln County. He died in Roswell in 1956 at the age of 84.

Pitser Chisum and James Chisum

The famous cattle king John Chisum had two younger brothers, Pitser and James, who also lived at South Springs River Ranch. Once, during the Lincoln County War, there was a plot to disfigure Pitser by slicing his ears in the same way the Chisums marked their cattle in a method called the "jingle-bob." The men also planned to brand Pitser with the Chisum Long Rail Brand. Thanks to Capt. J.C. Lea of Roswell, Pitser escaped unharmed. Pitser is shown above, and James below. A story told in Walter Noble Burns' *The Saga of Billy the Kid* states that the three Chisum brothers planted three cottonwood trees in close approximation to each other and then bound them together, so that they grew as one.

Addison Jones

When asked about Addison Jones, old-time cowboys would often say that he was the most famous African American cowboy of the Old West. Jones was known all the way from Toyah, Texas, to Las Vegas, New Mexico. In the late nineteenth and early twentieth century, Jones was a top hand at three very prominent ranches: the LFD, the Four Lakes, and the Yellow House. Jones was born as a slave in Gonzales County, Texas, in 1845. He was freed by the Littlefield family in June of 1865, whom he then began working for. It was in 1883 that Addison Jones, or "Add" for short, came to the Pecos Valley with George Littlefield and J.P. White. Add was quite renowned for his skill with horses, and some said he could "read a horse's mind by staring it in the eye." Add was so beloved that when he got married every ranching outfit in the area wanted to send him a gift; the only problem was they all unknowingly sent the same gift. Add and his bride went to the Roswell freight depot to find 19 cooking stoves waiting for them! A folk song was even written about Add called "Whose Old Cow?" in the 1908 book *Songs of the Cowboys*. Add kept on working the range until, as one man put it, "the wool on his head was almost as white as snow." Add passed away in Roswell on March 24, 1926, and was buried there in South Park Cemetery. No known photographs of Jones exist; above is an artist's conception of him.

CHAPTER TWO

Pioneers: Patriarchs, Farmers, and First Settlers

Settlers began to flock to Roswell just as the Wild West era was winding down. Thanks to the effort of town patriarch Joseph C. Lea, the Lincoln County War and Billy the Kid for the most part kept out of Roswell. After the Lincoln County War came to an end with the climactic burning of the McSween home in Lincoln, a new problem arose in the form of rampant cattle rustling. John Chisum teamed with Captain Lea to find a suitable sheriff to rid Lincoln County of Billy the Kid and other rustlers. Pat Garrett was elected and successfully managed to capture and kill most of the rustlers, including Billy the Kid whom he shot in 1881.

It was during the 1880s that Roswell saw enough growth to eventually become its own county seat. In 1889, Captain Lea, Pat Garrett, and land developer Charles B. Eddy set out together to the Territorial Council and House in Santa Fe to petition the creation of two new counties out of Lincoln. Their requests were granted and Chaves County was created with Roswell as the county seat, and to the south Eddy County. Chaves County was nearly named Lea County, but the good captain declined and instead insisted it be named for his friend Col. J. Francisco Chaves.

Captain Joseph C. Lea

Lea was born in Tennessee, but raised in Missouri. When the Civil War broke out, Lea joined Quantrill's Confederate guerrillas. He also served in Shelby's cavalry, but for much of the war Lea was captain of his own men in Louisiana. It is rumored he also rode for a time with Jesse and Frank James in a regiment. After the war in 1878, he arrived in Chaves County. Lea quickly became one of its leading citizens, both in business and public service. Lea and financial backers started a large ranching venture: Lea Cattle Company, which owned land available for development. The company developed Pecos Valley farmland by building irrigation ditches. He was a force for peace during the Lincoln War and played a major role in ridding the county of Billy the Kid. In 1885, he donated the land the city municipalities were built on and his brother laid out the city blocks and streets. His organizational efforts, public service, and leadership earned him the title of "Father of Roswell." Lea was one of the leaders in the creation of Chaves County in 1889. Lea persuaded Colonel Goss to establish Goss Military Institute and then provided the land and money to build the fledgling school. Later, Joseph Lea was instrumental in getting a bill passed by the Territorial Legislature establishing New Mexico Military Institute. He was appointed to the first board of regents of the school. In 1903, he was persuaded to run for mayor of Roswell. He died a couple of months after taking office from pneumonia at the age of 62. After his death the *Roswell Daily Record* wrote, "Capt. Lea was in almost every respect a remarkable man. In stature he stood six feet and four inches and his nobility of nature was as far above that of the average man as he exceeded him in stature . . . No worthy person ever applied to him in vain."

Capt. Joseph C. Lea and Sallie Lea

Left are pictured Capt. Joseph Lea's first wife Sallie Wildy Lea and their children, daughter Ella and son Wildy, c. 1883. Sallie was the daughter of established cotton planter W.W. Wildy from Yazoo County, Mississippi. She died in Roswell in 1884, leaving Captain Lea a widower in his young hamlet of Roswell. Lea eventually remarried to Mable Doss Day, called by some the "Cattle Queen of Texas," in 1889. From her Lea inherited a stepdaughter, Willie Day. Below can be seen Captain Lea, far right, in his later years during the drilling of one of Roswell's first artesian wells. Captain Lea played a prominent part in shaping Southeast New Mexico, and he was instrumental in turning the Pecos Valley area into one of the state's leading regions.

Sheriff John W. Poe

Most people know Poe, right with his wife Sophie, as Pat Garrett's deputy the night in Fort Sumner when Billy the Kid was killed. Poe would later beat out Garrett to become sheriff of Lincoln County and later beat Garrett again in an election for sheriff of Chaves County. In 1890 Poe, along with E.A. Cahoon (the man to Poe's right below), helped to open the first bank in Roswell. The Bank of Roswell opened that July with a capital of $50,000. Cahoon was another prominent Roswell resident. The park that was named after him is still well loved in Roswell today. Poe died in 1923.

Sophie Poe

Sophie Alberding came to Roswell in a roundabout way thanks to Capt. Joseph C. Lea. At the time, Sophie's brother Frank was under the employ of Lea, which is why Alberding set out for "dangerous New Mexico Territory" from her home in California. She became good friends with Pat Garrett, John Chisum, and Captain Lea. Many say it was Lea and Garrett who introduced Sophie to Garrett's former deputy John W. Poe. The two were happily married in 1883 and spent most of their lives in Roswell, though in 1913 they took a year-long vacation and traveled around the world, including stops in exotic places like Egypt. Sophie Poe authored a book on her life called *Buckboard Days*. Below is the Poe farm in Roswell.

J. B. "Billy" Mathews

Mathews was a Lincoln County War veteran present for a number of its more famous gun battles, including the murder of English cattleman John H. Tunstall. Mathews was also one of the few men to ever wound Billy the Kid in a gunfight. Later, Mathews became an influential figure in Roswell and served as postmaster from 1898 to his death in 1904.

Martin Van Buren Corn

The Corn family was one of the most influential in Roswell's history. The first Corn, Martin Van Buren Corn, below, arrived in Roswell in 1879 with his 11 sons: Charlie, Martin, Bob, Waid, Lee, George, Jess, Clarence, Poe, Hub, and Roe. Upon arriving in Roswell, Corn bought up 384 acres of land north of John Chisum's South Spring Ranch. Corn's many descendants still live in Roswell today.

Charles Ballard

Above is the Ballard family; standing left to right are Charles, Ann, Berta, and Will. Sitting left to right are Kate, Robert, Jim, Katie, Dick, and J.W. Charles Ballard led quite an adventuresome life. Ballard came to Roswell with his family in 1878 at the age of 12. In 1898, the well-respected Ballard recruited a contingent of 25 men to go and serve in the Spanish-American War. The next year, Ballard also expediently recruited 35 men to serve in the 11th US Cavalry Regiment to go all the way to the Philippine Islands. Ballard did quite a bit of nonmilitary traveling as well, visiting the Galápagos Islands, South America, and Central America on business trips to determine their suitability for cattle ranching. Ballard also served as Chaves County's sheriff (1907–1912). Below is shown Ballard's Saloon.

John James Hagerman

Hagerman was an American industrialist, a mine owner, railroad man, and owner of corporate farms. He was one of the most influential men in territorial New Mexico. He was born March 23, 1838, near Port Hope, Ontario, to parents of Scandinavian descent. The family moved to the state of Michigan in 1843 and became naturalized US citizens in 1848. J.J. contracted pulmonary tuberculosis in 1873. Although he recovered, his health was greatly weakened for the remainder of his life. For a time, Hagerman and his family moved to Europe in 1881, but they returned to the United States in 1884. He moved to the West and finally to New Mexico hoping that the dry air and high altitude would continue to improve his health. Eventually, he purchased the old South Spring River Ranch (though he didn't move there permanently until 1900) where he founded the nearby town of Hagerman to meet his needs and financial interests. Before coming to New Mexico, in 1890 Hagerman convinced the Pecos Valley Railroad to build a railroad from Pecos, Texas, to Eddy, New Mexico, to make it easier to take goods to market. The discovery of artesian wells in 1890 extended the railroad north to Amarillo, Texas. The railroad came to Roswell and Portales in 1894, and later reached the Panhandle and Santa Fe Railroad at Texico in 1899. While all this railroad construction was going on in the 1890s, Hagerman formed the Pecos Irrigation and Improvement Company to create more farmland by slowly assuming control of a private irrigation project throughout the Pecos Valley. His company started developing an irrigation system for the entire valley. He soon built the 45-foot-high Avalon Dam on the Pecos River in 1891, the first of its kind. Hagerman's company also built the McMillan Dam in 1892, which was nine miles upstream from the Avalon site. The Avalon Dam was washed out in an 1893 flood that also damaged the McMillan Dam. Hagerman repaired the structures despite the economic depression at the time. Both dams were back in business by 1894.

Hagerman Home and Private Train Car

In 1894, Hagerman's partners in the irrigation business sold their interest and that year's crop experiments failed to meet expectations. By 1898, the Pecos Irrigation and Improvement Company declared bankruptcy. On the same day the company was sold in 1900 to the Pecos Irrigation Company, yet another flood washed out the wooden flume again. Hagerman's health started to fail by the end of 1900 and he went back to Europe. He died in Milan, Italy, on September 13, 1909. Hagerman contributed greatly to the development of Chaves and Eddy County. The construction of the railroad and the irrigation systems might not have happened without his financial support. J.J. Hagerman should be considered as one of the most influential men in Southeast New Mexico's history if not the history of the entire state. Above is Hagerman's Roswell home and below his private train car.

Governor Herbert J. Hagerman

Hagerman was born in Milwaukee, Wisconsin, in 1871 and came to Roswell thanks to his father J.J. Hagerman. He was appointed governor of New Mexico in January 1906. Before that, he had served as second secretary at the US Embassy in Russia from 1898 to 1901. H.J. Hagerman lived in Roswell for much of his life but passed away in Santa Fe in 1935.

Louis Fullen (OPPOSITE PAGE RIGHT)

Fullen, the young man to the far right, helped to begin Roswell's first newspaper and also ran his own paper in Las Vegas, New Mexico; he would later become one of New Mexico's best lawyers. Fullen was especially well versed in water laws. He once said he believed fights over water in New Mexico caused more murders than fights over women. Fullen passed away in Roswell in 1950.

Loney K. Wagoner and Blackdom (OPPOSITE PAGE LEFT)

The town of Blackdom in between Roswell and Artesia was founded by Frances and Ella Boyer, who dreamed of a townsite where African Americans could settle together. The land where they settled had previously been scoped out by Frances's father Henry Boyer, who hailed from Pullam, Georgia. The town's population topped at 300 and had to be abandoned due to a water shortage in the 1920s. In its day, the town had a post office, general store, and a Baptist church which also served as a schoolhouse. The rest of the area was made up of various homesteads. The photograph above shows the schoolteacher Loney K. Wagoner (far right) and his students. Wagoner's descendants still live in Roswell today. Thanks to the efforts of Reverend Landjur Abukusumo and other Roswellians, a historic marker now stands near the former townsite.

Littlefield Cattle Company.

J. P. WHITE, Manager.

P. O.: Fort Sumner, N. M. Range, at Bosque Grande, Rio Pecos.

Horse brand and Also cattle in the following brands: on the side, L F W on hip, side and shoulder; J — O on shoulder, side and hip; on the right side and on on the the right hip. For these shoulder, side and hip. brands various earmarks.

George W. Littlefield

Littlefield was born near Como, Mississippi. He moved to Texas at the age of nine with his family. During the 1860s, he fought in the Civil War on the side of the Confederacy eventually garnering the rank of major. In 1881, he came to New Mexico with his nephews J.P. and Tom White, where they established the LFD (Littlefield) Cattle Company, an old ad for which can be seen left. Some people even claimed that at the time of his death George Littlefield was the richest man in Texas.

James Phelps White

White was born on December 2, 1856, in Gonzales, Texas. He came to the Roswell area with his uncle George W. Littlefield in 1881 where they established the LFD Ranch at a former location of John Chisum's, the Bosque Grande north of Roswell. "J.P." or "Phelps" as he was often known to his friends, expanded his operations to other locales, such as Four Lakes, the Yellow House Ranch in Texas, and what would eventually become the Texas town of Littlefield. By 1920, J.P. White was reputedly the wealthiest cattleman in New Mexico since John Chisum. Writer Cecil Bonney said of White, "J. Phelps White was a real cowpuncher in every sense of the word: good with a rope, good on a horse, and experienced on the range." As the town of Roswell continued to prosper, White took great interest in its affairs. He served on the board of regents for NMMI for 22 years, and he was also a charter member of the Roswell Masonic Lodge, which he helped to organize in 1889. White passed away in San Antonio on October 21, 1934, leaving behind a wife, three sons, and a daughter. Today White's grandchildren and great-grandchildren still have successful businesses and influence in Roswell.

James Phelps White and J.P. White Building

The photograph above shows J.P. White (the man on far right, man on left is unidentified) when he first arrived in the Roswell area. White grew to become a very influential businessman in Roswell under the heading of J.P. White Industries. White bought the building below, then called the Allison building, and added an additional three stories to it. Today, it is appropriately called the J.P. White Building.

Lou Tomlinson White

J.P. White first met his future wife Lou Tomlinson at the Roswell Post Office in 1899. The two were married in 1903. In 1912, D.Y. Tomlinson, Lou's father and a well-known contractor, built for them a magnificent home, which Mr. and Mrs. White stand in front of above. Below, Lou White, fifth from left bottom row, poses with her fellow members of the Daughters of the American Revolution (DAR). The DAR still meet at the White Home today, now the headquarters of the Historical Society for Southeast New Mexico. Mrs. White was also a charter member of the First Presbyterian Church of Roswell, and was a valued contributor to Roswell's religious, civic, and social affairs. She lived in the house until her death in 1972 at the age of 92.

Governor James F. Hinkle

From being the mayor of Roswell to being the governor of all of New Mexico, Hinkle wore many hats in his adventurous lifetime. He first came to New Mexico in 1885 from Missouri, where he was born in 1863. After only one year in New Mexico, at the young age of 23 Hinkle was made foreman of CA Bar Ranch in the Lower Penasco region of what is today Chaves County. Hinkle would fill the role of manager of the Penasco Land and Cattle Company for 15 years. During his years living in Lincoln County (the Penasco had not yet been annexed to Chaves County), Hinkle met his future wife, Lillian Roberts, at a gathering in Lincoln town. The two were married December 14, 1892, and their first child was born in the historic location of Dowlin Mill in Ruidoso. Hinkle began his political career in 1892, when he was elected into the Territorial Legislature to represent Lincoln, Chaves, and Eddy Counties. He held various other political offices including being the first mayor of Roswell, replacing the late Captain Lea who became ill instantly after being elected in 1903. During his time as mayor, Hinkle issued a law making gambling illegal in Roswell. A small area outside of Roswell was created where gamblers could go to indulge in their habits. They named their little mini-town Hinkle (though it only survived a year). After New Mexico became a state in 1912, Hinkle became the first state senator to be elected from Chaves County. In 1922, he was elected governor, serving one successful term, then choosing not to run for two even though he could have easily been re-elected. In his later years, Hinkle became president of First National Bank in Roswell, a position he held from 1934 until his death on March 26, 1951.

James F. Hinkle and Family

Above is the entire Hinkle family; from left to right in between Mr. and Mrs. Hinkle are children Lillian, 4, Vera, 12, Clarence, 9, and Rolla, 17. Below can be seen Mrs. Hinkle reclining on her porch in later years. Of Mrs. Hinkle (when she was still young Miss Roberts) George Curry, a close friend of Jim's said, "I remember that I considered Miss Roberts one of the most beautiful women I had ever seen. I was sure something was going to happen some day when I saw how Jim was looking at her."

John B. Gill

Roswell's oldest continually operating business in town is that of Roswell Seed, which began as the Roswell Produce and Seed Co. The business seen below was founded in 1903 (though some records speculate it could have begun sooner) by John B. Gill, who was born in Tennessee in 1848. The store has switched locations around Roswell's Main Street over the years, starting on the east side south of 2nd Street, next moving to the corner of 2nd and Main, and then in 1909 when the name was shortened to Roswell Seed moving to 115-117 S. Main. A fire destroyed most of that building in 1964, after which it was repaired and partially rebuilt where it still stands and operates to this day. Above is Walter Gill, a son of John B. Gill.

Jaffa, Prager and Co.

Roswell's first department store was Jaffa, Prager and Co. shown left. The men responsible were Nathan S. Jaffa and William Prager, who first opened a store at the Chisum ranch before moving it to Roswell in 1886. Among the men outside the store above are Pat Garrett and Roswell's first doctor James Sutherland.

Joyce Pruitt and Co.

Roswell's other best-known store in the old days was Joyce Pruitt and Co. It began as Pennebacker-Joyce Co. in Eddy, before Pennebacker was bought out by Albert Pruitt and moved to Roswell in 1893 where it operated until 1929. Above is the Joyce Pruitt Co. offices, in which can be seen Frank Joyce and Albert Pruitt (first two men at left respectively) c. 1920.

Rufus J. Dunnahoo

Dunnahoo is another prominent family name in Roswell thanks to the many descendants of Rufus H. Dunnahoo. Dunnahoo, a former Texas Ranger, came to Roswell in 1881 to become the town's first blacksmith. His son Rufus J. Dunnahoo and family are seen right including son Alex, daughter Kate, and wife Mardy "Lady Chewning" Dunnahoo.

Juan Chaves y Lopez

Juan Chaves y Lopez was one of the earliest Hispanic settlers in the Roswell region. He lived in his adobe home seen here near the Pecos River, where he operated Juan Chaves Crossing with his ferryboat, which he would use to take people across the river. He operated the business until a bridge was put over the river in 1902.

Lucius Dills

Dills was the first editor of the *Roswell Record* in 1891 and wrote a wealth of information on the area. He is seen here with his wife Gertrude. Dills passed away in Roswell in 1944. In 2011, Dill's long unpublished manuscript, *Dill's History of Chaves County*, was finally printed thanks to Morgan Nelson. It offers a unique first-person perspective on early Roswell history.

G.A. Richardson

Roswell's first attorney, Richardson not only played a role in the reorganization of Roswell's government, but he was also involved in the Lea Cattle Company and in the creation of New Mexico Military Institute. Like many other famous Roswellians, he has a street in town named in his honor.

Capt. Charles W. Haynes

The swampy but beautiful area pictured below is in the area of present-day Cahoon Park in Roswell. At the time this photo was taken, the area was known as Haynes' Park and Natatorium, and it came complete with bathhouses, boats, a swimming pool, and even a powerboat that took people up river. The mastermind was Capt. Charles W. Haynes, left, who diverted water from North Spring River to make the lush park. Captain Haynes was also sheriff of Chaves County for a time, replacing Charles Perry who absconded with county funds to Mexico. Haynes' Park unfortunately dried up in the 1920s along with North Spring River.

CHAPTER THREE

Superstars: Athletes, Actors, Artists, Inventors, Musicians, and Writers

Roswell has been the birthplace, hometown, and the frequent "stomping grounds" of more celebrities than one would think. Several movie stars lived and ranched here during the 1930s, but Roswell's best-known "superstars" are likely actress Demi Moore and singer John Denver.

Denver was born in Roswell while his father was stationed at the airbase in 1943. He later became a solo artist and released over 300 songs, receiving 12 gold albums and four platinum albums during his career. He was killed while piloting his plane at age 53.

Demi Moore was born Demi Gene Guynes in Roswell and attended grade school and middle school here. After her family moved to Los Angeles, at age 16 Moore dropped out of school with hopes of becoming an actress. She had several minor roles in films and on *General Hospital*, a TV soap opera. Moore was often considered part of the group of young actors nicknamed the Brat Pack by the media. Her big break came in 1985 with her part in *St. Elmo's Fire*. In the early 1990s, she starred in *Ghost*, *A Few Good Men*, and *Indecent Proposal*, making her the highest-paid actress in Hollywood. In 1991, Moore became one of the four founding movie star investors in the international restaurant chain, Planet Hollywood. She has been married three times, her most famous marriages being to action star Bruce Willis, and recently to younger man Ashton Kutcher. Moore occasionally comes back to Roswell, often in secret, to visit her relatives here.

Elizabeth Garrett

Elizabeth Garrett was the daughter of famous lawman Sheriff Pat Garrett, who killed Billy the Kid. This, however, is not why she is famous. Elizabeth was born blind on October 12, 1885, and was the third of eight children born to Pat and Apolinaria Garrett. Elizabeth's disability never hampered her love for music, and she learned to play the piano at a young age. Not only could she play, she could also sing beautifully. Soon Elizabeth was a singer, songwriter, and even a music teacher. In 1917, she sang her composition "O, Fair New Mexico" to the New Mexico Legislature, which quickly and unanimously voted to make it the official state song. Garrett became known affectionately as the "Songbird of the Southwest" and even performed in illustrious theaters in Chicago and New York.

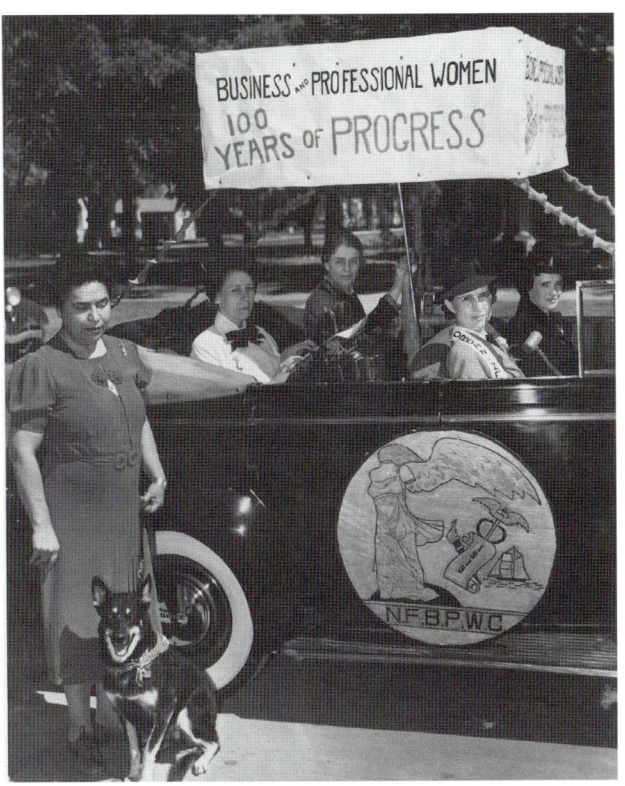

Garrett's Death

Garrett called Roswell home, where she lived in her beloved "casita" with various seeing-eye dogs over the years. Garrett died in Roswell, ironically on the night of a mysterious blackout on October 16, 1947. She was found by several of her friends, who discovered she had tripped and fallen onto the pavement tragically killing her. Garrett had many friends in Roswell and across New Mexico, the state she had honored so well with her beautiful composition. One thing is for certain, the Songbird of the Southwest definitely flew out from her legendary father's shadow rather than remaining under it. Left shows Garrett in the group Business and Professional Women, and below she is shown at a performance.

Col. Maurice G. Fulton

Fulton, right, was the head of the English department at NMMI for more than 20 years. A bio for Fulton at the Historical Society says that he "probably did more original research and historical collecting on areas than any three or four people combined." He is best known for his book *Maurice G. Fulton's History of the Lincoln County War.*

Cecil Bonney

Bonney is the author of one of the more beloved books on Roswell, *Looking Over My Shoulder: Seventy-Five Years in the Pecos Valley.* Bonney grew up in the area and knew such men as Pat Garrett and the Coe Brothers of Ruidoso. Bonney was a special correspondent for the *El Paso Times* and also wrote for the *Roswell Daily Record* and *Roswell Morning Dispatch.*

Guy Kibbee

During the 1930s and 40s, Kibbee was one of the most successful bit part actors in the business. In a span of only five years, he once appeared in as many as 50 films, notably *Mr. Smith Goes to Washington* and *Little Lord Fauntleroy*. Though he wasn't born there, Kibbee considered Roswell his home and spent most of his childhood there because his father James Kibbee for a time owned the *Roswell Register*. Above shows Kibbee in a still for *Little Lord Fauntleroy* and below in *H.M. Pulham, Esquire* c. 1941.

Dr. Robert H. Goddard

Goddard was a true rocket scientist, creating the first liquid-fueled rocket along with 214 patents concerning rocket flight. He was an inventor, professor, physicist, and visionary. Goddard is known as the "Father of Modern Rocketry." He was the first to launch a liquid-fueled rocket in Massachusetts in 1926. Goddard's significant achievements in rocket propulsion have contributed immensely to the scientific exploration of space. Goddard didn't receive much public attention for his work and was often ridiculed. He became a private man and protective of his work. It wasn't until the space race, years after his death, that he and his work were appreciated. In 1930, with financial support from Charles Lindbergh and Harry Guggenheim, Goddard moved his operation to Roswell, New Mexico, and the wide open space there. Lindbergh and Guggenheim were frequent visitors to Roswell and would fly in to visit Goddard to see how their investment was working out. While living in Roswell, he did much of his experimenting and testing north of town. His home was at a separate location at the east end of Mescalero Road, just east of Atkinson. (NASA photograph courtesy Roswell Museum and Art Center.)

Replica of Goddard's Workshop

In an exhibit at the Roswell Museum and Art Center, shown above, you will find a complete replica of Goddard's workshop, many of his machine tools, documents, and the first liquid-fueled rocket along with other test rockets of Goddard's. Included in the display is his launch tower brought in from its original site north of town. Goddard died on August 10, 1945, not realizing just what he had done for his country and the world. All rockets today use Goddard's basic principles of flight and propulsion. The photograph left shows the good doctor taking a break from his work to paint a picture. The back of the photograph reads "painting desert flowers on a Sunday 1936." (Above courtesy Roswell Museum and Art Center; left NASA photograph, courtesy Roswell Museum and Art Center.)

Esther Goddard

Left are Esther Goddard and her husband, the famous "rocket man." Pictures of Dr. Goddard and his wife together are rare because it was often her behind the camera. Esther met Dr. Goddard in 1919 when she was the secretary in the office of the president of Clark University. Though he was 20 years her senior, the two fell in love and married in 1924. Esther did a great deal to help Goddard with his research, including sewing parachutes and even stamping out brush fires from his rockets! She was also the only one who could decipher his handwriting. In Roswell, Esther was part of the Roswell Woman's Club and began a book club that still exists today. Below shows Esther with Paul McEvoy, likely after her husband had passed in 1945. (Left NASA photograph courtesy Roswell Museum and Art Center.)

Charles Lindbergh and Harry Guggenheim

Lindbergh, the aviator famous for flying across the ocean in *The Spirit of St. Louis* in 1927, often came to Roswell to visit his friend Dr. Robert Goddard. Lindbergh is the tall man second from right next to Goddard. On Goddard's left is his other major benefactor, Harry Guggenheim. (NASA photograph courtesy Roswell Museum and Art Center.)

Charles Mansur

One of the main members of Dr. Robert Goddard's crew was Charles Mansur, left. He helped with nearly every aspect of the rockets, from launching them to cleaning them up when they came down. The rockets were often outfitted with parachutes in hopes that when they came down they would be salvageable. With Mansur above is Addie Bond.

Leonard Slye aka Roy Rogers and Arline Wilkins Rogers

Roy Rogers starred in western movies, was a western singer, and had his own TV show. He was dubbed the "King of the Cowboys" by Hollywood. Rogers was actually born Leonard Slye to Mattie and Andy Slye of Cincinnati, Ohio, on November 5, 1911. Roy met and married his first wife, Arline Wilkins, left, while performing in Roswell on the local radio station KGFL. The two met over a discussion of who made the best lemon pies: girls of that day or women like his mom? Arline and her mom showed up with pies for Roy to try. This was the beginning of a long-distance romance. They were married in Roswell in 1936 as seen in the photograph left. Above is Roy, second from left, when he was part of the O Bar Cowboys in 1933.

Leonard Slye aka Roy Rogers

After four years of marriage, Roy and Arline adopted a four-month-old daughter, Cheryl Darlene. Three years later, Arline gave birth to a girl Linda Lou and in 1946, Arline Rogers gave birth to Roy Rogers Jr., who they called "Dusty." Less than a week later, while she was still in the hospital, Arline unexpectedly developed an embolism and died. Now, with three kids and trying to advance his career in the entertainment business, Roy needed help. He had met actress Dale Evans earlier while doing a movie with her. The two started dating and it wasn't before long that the "King of the Cowboys" married the "Queen of the West" and the duo became a "Hollywood power couple" of their day and the rest is history. Roy went on to star or sing in over 100 movies (often with Dale and his equally famous horse Trigger) and was a TV star with his own show, *The Roy Rogers Show*, from 1951 to 1957 on NBC. He was one of many kids' Saturday morning favorites during the 1950s and 1960s. Rogers died of congestive heart failure on July 6, 1998. He was buried at Sunset Hills cemetery in Apple Valley, California. Above is Roy in the 1970s performing at Knott's Berry Farm. (Courtesy Orange County Archives.)

Peter Hurd

Hurd is considered the greatest "favorite son" artist of New Mexico. Hurd was born Harold Hurd Jr., in Roswell, New Mexico. He legally changed his name to "Peter," since he was nicknamed Pete by his parents. Hurd attended the local public schools, St. Peter Catholic School, and later the New Mexico Military Institute in Roswell where he became close lifelong friends with author Paul Horgan. He received an appointment to West Point in 1921, but dropped out to study art. At Chadds Ford, Pennsylvania, he met N.C. Wyeth, who invited Hurd to study with him. There, Hurd met and married Wyeth's daughter, Henriette Wyeth, a renowned still life and portrait painter in her own right in 1929. The Hurds bought a *hacienda* in San Patricio, New Mexico, in 1934. Many celebrities made their way to the Hondo Valley to have their portrait painted by either Peter or his wife. The Works Progress Administration (WPA) commissioned Hurd to paint murals in many post offices and other public buildings in the 1930s. This brought national attention to the artist, as did an article in *Life* magazine. During World War II, Hurd was a war correspondent for *Life*, recording the war in paint. In the 1950s, Hurd painted his "masterpiece," a mural in the museum at Texas Tech. Some of Hurd's most significant works can be found in the Roswell Museum and Art Center. Hurd was in the national news in 1966 and 1967 when he painted the official portrait of President Lyndon Johnson. Johnson said it was "ugly," and rejected it. The Smithsonian purchased the portrait, where it now hangs as LBJ's official portrait. Peter Hurd died in his hometown of Roswell in 1984.

Henriette Wyeth Hurd

Henriette Wyeth was the eldest daughter born to Newell Convers ("N.C.") Wyeth and Carolyn Wyeth on the East Coast of the United States. Wyeth was a famous artist and illustrator, and among his most famous projects was doing the original illustrations for such classic books as Jules Verne's *Mysterious Island.* Henriette began studying under her father at the age of 11. Despite a crippled right hand from a childhood struggle with polio, Henriette was determined to become a painter like her father. At 13, she attended the Normal Art School in Boston and later the Pennsylvania Academy of the Fine Arts. Henriette met her future husband Peter Hurd while he studied under her father at Chadds Ford, Pennsylvania. The two married in 1929 and moved to San Patricio, New Mexico, making Henriette the only Wyeth to permanently leave the East to move to the West. Wyeth was best known for her still lifes, florals, and portraits. Among those she painted were actress Helen Hayes, author Paul Horgan, and First Lady Pat Nixon. Wyeth is considered by many art scholars to be one of the greatest woman painters of the 20th century. Her work can today be found at the Roswell Museum and Art Center and the Hurd-La Rinconada Gallery in San Patricio among other places. (Courtesy Michael Hurd and the Hurd-La Rinconada Gallery in San Patricio.)

Peter and Henriette Wyeth Hurd

Many famous people visited the Hurds, above, at their Sentinel Ranch in San Patricio, among them horror star (and art collector) Vincent Price, below, Burl Ives, Helen Hayes, Linda Darnell, Charles MacArthur, and even a royal prince from Thailand.

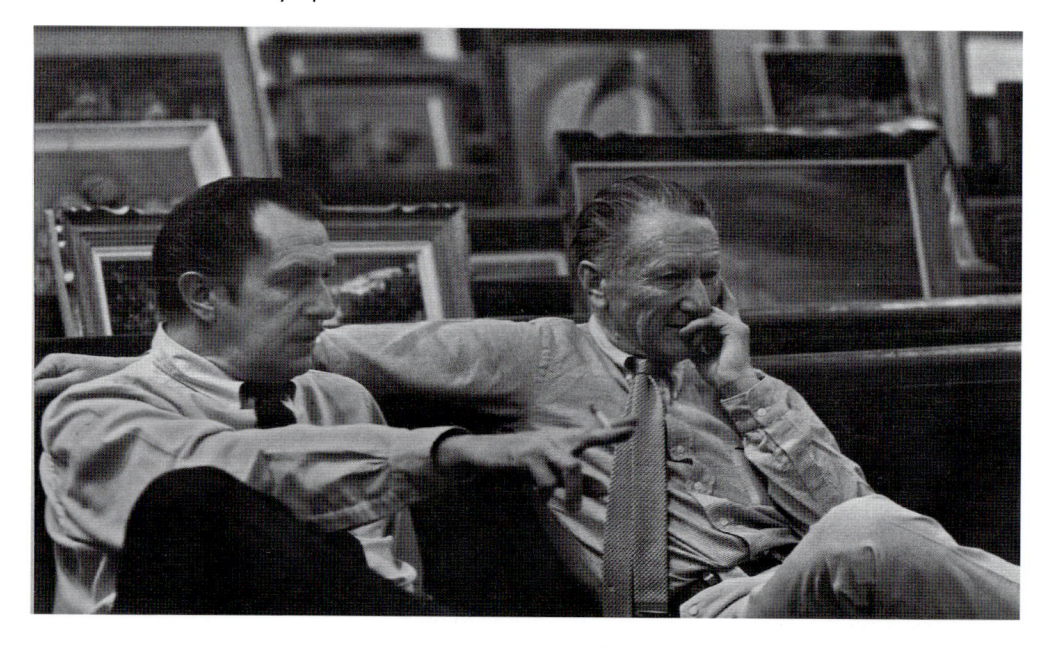

Pete Jaquess

Pete Jaquess was born Lindel Glenn Jaquess in Earth, Texas. He and his family later moved to Roswell. He was an outstanding collegiate football player for Eastern New Mexico University. He was drafted in 1964 by the American Football League as a defensive back. He was the fourth pick of the 20th round, 158th overall. Pete was an All-Star his rookie year with the Houston Oilers. He played two years for the Oilers, two years for the Miami Dolphins, three years for the Denver Broncos when they were part of the AFL, and one year for the Broncos in the NFL.

Robert "Bob" Crosby

Robert A. "Bob" Crosby was a top rodeo performer for 30 years; he won the title of "World Champion Cowboy" in 1925, 1926, and 1928, thus receiving the Roosevelt Trophy permanently, which is awarded to three-time winners. Crosby roped and rode in numerous major venues all over the world. He owned the Cross-B Ranch northeast of Roswell at Kenna, New Mexico. He owned several businesses in Arizona and in Roswell, most notably the Green Lantern Saloon. In 1947, Crosby was killed in a jeep accident near his ranch when he somehow missed the bridge at Acme Draw northeast of Roswell. Acme Draw was renamed "Bob Crosby Draw" in his honor.

Bob Crosby

Crosby's trophies, saddles, and other memorabilia were displayed in their own room at the Roswell Museum and Art Center for a few years starting in 1951. Eventually the collection was moved to the National Cowboy Hall of Fame in Oklahoma City. There is a small display of some of Crosby's belongings and photographs, including his saddle, in the Historical Center for Southeast New Mexico in Roswell. Above are two shots of Crosby performing in one of his many rodeos.

Ora A. Woodman aka Uncle Kit Carson

One of the more interesting "folk heroes" to call Roswell home was Uncle Kit Carson, a former performer from Buffalo Bill Cody's Wild West Show. Carson claimed to be the nephew of the famous Indian fighter Kit Carson. Nearly everyone knew Uncle Kit, who loved to be the center of attention. Right, Uncle Kit rides in a 1940s Eastern New Mexico State Fair Parade with the American flag. The picture below is humorously labeled "Uncle Kit's Last Ride."

Uncle Kit-Father of Billy the Kid

In Uncle Kit Carson's possessions a letter was found dated August 1, 1949, which addresses Uncle Kit as "Dad." The letter is regarding the whereabouts of Billy the Kid, presumed to still be alive, and is signed by O.L. Roberts. In 1949, a man named O.L. "Brushy Bill" Roberts of Hico, Texas, surfaced claiming to be Billy the Kid and got national attention, including a meeting with New Mexico's then-governor Thomas Mabry. In the end, Brushy Bill was thought to be a fake. Coincidentally, it was later found out that Uncle Kit's real name was Ora A. Woodman, and he was neither the father of O.L. Roberts nor the relative of Kit Carson, just an eccentric circus performer who loved to tell stories.

Joe Willis Bauman

Bauman was born in Welch, Oklahoma, on April 16, 1922. He is best known for his time playing baseball with the Roswell Rockets of the Longhorn Baseball League. In 1954, Joe hit 72 home runs for the Rockets, then the highest total for a major-league or minor-league player ever. This record was finally broken in 2001 by Barry Bonds, who was later linked to performance-enhancing drugs. Bauman played for minor-league teams in the American Association, the Eastern League, and the Southwestern League. In 1952, Joe Bauman played in Artesia, leading the Longhorn League in batting average (.375), home runs (50), and runs batted in (157), winning the league's Triple Crown. He also led the league in walks with 148.

Joe Bauman, Hometown Hero

Bauman won the Triple Crown again in 1954 playing for the Roswell Rockets with even better stats. His batting average was .400, he drove in 228 runs, and his home runs amounted to a whopping 72. The fans would stick money in the backstop after each home run, as seen above. Bauman retired a few years later in 1956 at the age of 34 as a true hometown hero. After retirement, he ran his filling station, which he started during his baseball career. Joe died September 20, 2005, from a fall he incurred during a presentation naming the baseball field after him. Bauman can be seen in his prime hitting a home run in 1954 top.

The Roswell All-Stars

Left are the Roswell All-Stars who won the Little League World Series in 1956. In the back row left to right are Dick St. John—manager, Bill Turley, Ferrell Dunham, Blain Stribling, Tommy Jordan, David Smith, and Pete Ellis—assistant coach. Middle row left to right are Guy Bevill, Dick Story, Albert Palamino, and Mike Sandry. In the front row left to right are Teddy Garrett, Jim Valdez, David Sherrod, Randy Willis, and Harold Hobson.

Little League World Champions

To win the Little League World Series in 1956, the Roswell All-Stars had to travel to Williamsport, Pennsylvania, the "birthplace of Little League Baseball," to play against a team from Delaware Township, New Jersey. Above is an action shot from the game in Williamsport and below Harold Hobson runs to first base. The Roswell All-Stars won the game 3–1.

Lefty Frizzell

Frizzell was a country music star whose popular hits included "If You've Got the Money, I've Got the Time." What most people don't know is that Lefty wrote some of these famous songs while in jail in Roswell. Lefty was born William Orville Frizzell in 1928. He came to Dexter (near Roswell) after he married Alice Harper in Oklahoma when he was just 17. Soon, underage Lefty began playing at local bars for tips thanks to his uncle Johnnie Cox. Later, Lefty began playing live on Radio KGFL in Roswell and became very popular around town, so much so that he soon developed "groupies," one of whom he had an affair with. The 16-year-old girl, underage compared to Lefty, filed statutory rape charges on Lefty after he dropped her, which is how he eventually landed in the Chaves County jail.

Lefty Frizzell and Wanda Faye

After he was released from jail, Frizzell didn't stick around Roswell for long. His first record in 1950 was a "double sided hit" that earned him $36,000 in royalties on his first check. With this Lefty bought three new Cadillacs, a bus for his band, and an airplane. He occasionally came back to Roswell to visit, and in 1972 was inducted into the Songwriter's Country Music Hall of Fame. He died of a stroke in Nashville in 1975. In the above photograph, he poses with another Roswell musician, Wanda Faye, and her husband Bob Wolfe. Right is another image of Wanda Faye.

Wanda Faye

Faye was born Wanda Faye Narmore on October 24, 1929, to John and Bessie Narmore, and grew up on a five-acre farm in the 700-block of South Sunset Avenue in Roswell. Faye was a local singer who made it big in the Western Swing genre. She was inducted into the Western Swing Society's Hall of Fame in Sacramento on October 5, 2003. You can find some memorabilia that provides an interesting look into her career, including a number of celebrity photographs, in the museum of the Historical Center for Southeast New Mexico (HCSNM) in Roswell. By the time she was nine years old, Faye was not only singing but also playing the guitar and piano. In 1947, Lefty Frizzell, who was to later become a country superstar, had a live radio program on KGFL in Roswell, and he invited Wanda Faye to be his guest on the show. Soon Wanda was offered an opportunity to have her own program. She teamed up with her future husband, Bob Wolfe, to do the radio show. Her band called "The Sunset Westerners" included "Hondo Bessie" Narmore, Bruce Owens, and Gene Roberts. They entertained throughout the Pecos Valley for a number of years. During her career, Wanda Faye appeared on tours and concerts with many country music stars. To list them all would look like a "Who's Who" of country music. The photographs Wanda placed with the archives of the HCSNM depict Wanda Faye with Ernest Tubbs, Lefty Frizzell, Johnny and June Cash, Minnie Pearl, and others. Faye left Nashville in 1965 and toured the West. She settled down in California, where she and her second husband had *The Weldon Rogers and Wanda Faye TV Show* on KRCR in 1967 and 1968.

Louise Massey

Massey was a famous country singer and member of the Cowgirl Hall of Fame throughout the 1930s and 40s. She was born into a musical family in Texas in 1902. Her father was a violin player who encouraged Louise and her two brothers, Allen and Curt, to be musicians. These four were the first members of what would later be the "Massey Five," the fifth member being Louise's husband Milt Mabie of Roswell. who joined the family in 1919. The Massey Five was discovered when the Redpath Chautauqua came to Roswell in 1928 looking for talent and found the Masseys. The Massey Five began touring across the United States and Canada as early as 1928 and appeared on various radio stations and the national CBS radio network. In 1930, Henry, Louise's father, left the group to return to the Hondo Valley, while Curt became the leader of the Massey Five and added in a new member: Larry "Duke" Wellington, who played the accordion. In 1933, the Massey Five became Louise Massey and the Westerners when they joined the *National Barn Dance* show for NBC radio. The group gained an even wider audience when they joined *The Maxwell House Show Boat* and *The Log Cabin Dude Ranch*, both on NBC radio in 1935. After their radio success, the Westerners would even do a few short musical films of the "follow the bouncing ball" variety for movie theaters. Later, they sang and even acted in a major motion picture starring Tex Ritter called *Where the Buffalo Roam*.

Louise Massey and the Westerners

Louise Massey and the Westerners recorded many songs, but their biggest hits were "My Adobe Hacienda," "I Only Want a Buddy (Not a Sweetheart)" and "South of the Border (Down Mexico Way)." For a time "Adobe Hacienda" was No. 7 on *Your Hit Parade* for 10 weeks. This unfortunately didn't happen until 1947 when Louise Massey had semi-retired from singing. She and Milt moved back to Roswell in 1967. Milt passed away in 1973, and Louise in 1983 in a San Angelo, Texas, nursing home. The above image shows the group in Chicago c. 1934, and below are, left to right, Milt Mabie, Larry Wellington, Louise Massey, Curt Massey, and Allen Massey.

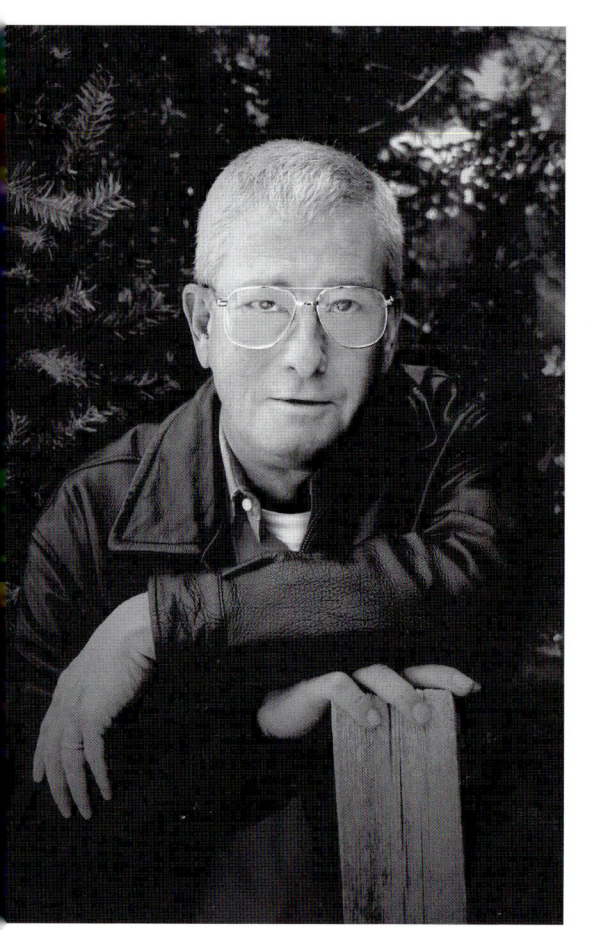

David Clary

Clary is the author of over a hundred publications in military, environmental, and scientific history, including eleven books. Clary has also held positions as Chief Historian for the US Forest Service, and a teacher of history at ENMU-Roswell and English at NMMI. He holds degrees from Indiana University and the University of Texas, and has received several honors and awards for his work in history, historic preservation, and public service. (Jack Rodden photograph, courtesy David Clary.)

Tom Brookshier

Brookshire was both an NFL football player and a famous sportscaster who hailed from Roswell. He was a starting Defensive Back for the Philadelphia Eagles from 1953 to 1961. He was selected to the Pro Bowl twice. His playing career ended due to a broken leg during a football game against the Chicago Bears in 1961. After this he became a well known sportscaster in the 1970s for NFL games on CBS. He passed away recently in 2010.

David Orr

Orr was a successful stage and national television actor for several years. He studied in California and New York and acted primarily in dramas and a few musicals. He returned to Roswell, his hometown, in 1960, to help operate his father's bakery. In the 1970s, Orr operated an art gallery and picture framing business on West 10th St. and also served as Director of the Historical Society for a time.

Willie Hall

Hall was a renowned Roswell boxer who came close to winning the National Golden Gloves title in 1952 among other titles and competitions such as the Air Force Championships. During the course of his career Hall even befriended Muhammad Ali when he was still known as Cassius Clay. In Roswell Hall coached hundreds of boys in boxing free of charge making him much loved across the community and was also inducted into the New Mexico Boxing Hall of Fame. Hall passed away December 6, 2011, in Albuquerque, New Mexico.

Roger Thomas Staubach

Dallas Cowboy Hall of Fame quarterback Roger Staubach was born in Cincinnati, Ohio, on February 5, 1942. Staubach has two Super Bowl rings (including the Cowboys' first win there) and a Heisman Trophy. He was the MVP of Super Bowl VI, was named to the Pro Bowl six times, and was elected to the National Pro Football Hall of Fame. Staubach joined the Cowboys in 1969 and played for 11 years after serving his obligation to the US Navy, which included a tour of duty in Vietnam. The Naval Academy retired his jersey upon graduation, and his name is among the Ring of Honor in the Dallas Cowboys Stadium. Before his glory days as a quarterback, Roger attended the New Mexico Military Institute where he played as quarterback for the Broncos in Roswell as seen on this page.

Orval Kisselburg aka the Daredevil Clown

Kisselburg began his daredevil career in Roswell walking the girders and swinging on cables underneath the old Pecos River Bridge. He performed stunts on the speedway and at various county fairs from 1952 until 1982. Kisselburg's various stunts included precision driving, auto jumps (as seen below), and even stunts with explosions. Over this time, Orval befriended Evel Knievel, once even performing a stunt for the injured Knievel. In 1972, Orval rescued a young man from drowning in the Jordan River in Salt Lake City, one of his proudest moments and certainly the most heroic. He was forced to retire when he contracted Lou Gehrig's Disease in 1983. He passed away in Salt Lake City in 2008. He is shown right in 1950 at the age of 28.

Nancy Lopez

Lopez was born in Torrance, California, on January 6, 1957, and raised by Domingo and Marina Lopez in Roswell, New Mexico. She attended Flora Vista Elementary School, Mesa Middle School, and Goddard High School. Flora Vista Elementary has since been renamed Nancy Lopez Elementary School in her honor. A pace setter, Nancy played on the boys' golf team at Goddard High School since there was no girls' golf team at that time. She led Goddard to two state titles while attending school.

Nancy Lopez

Lopez, a member of the PGA World Golf Hall of Fame, is known as the greatest female golfer of her generation. She has won 48 LPGA tournaments, including the LPGA Championship in 1978, 1985, and 1989. Among her many achievements, Nancy was named LPGA Rookie of the Year, the Associated Press Female Athlete of the Year, and was featured on the cover of *Sports Illustrated*. She also was honored with the Hispanic Heritage Award. Nancy is married to former New York Mets and Cincinnati Reds third baseman and World Series champion Ray Knight. They have three daughters: Ashley, Erinn, and Torri.

Joel McCrea and Frances Dee

McCrea, an actor who appeared in over 90 films, was born in Pasadena, California, on November 5, 1905. About the same time he married actress Frances Dee (above with McCrea) in 1933, McCrea started buying up property and ranches. One such ranch was outside Roswell, New Mexico. McCrea and Dee had three sons, David, Peter, and Jody. David became a rancher and still ranches around Roswell. Peter followed his father's passion of purchasing property and became a real estate developer. Jody picked up his father's hobby, the acting profession, and lived in Roswell until his death. Joel McCrea considered himself an outdoorsman and rancher and stated acting was just a hobby. By the end of the 1940s, he had become a multi-millionaire between his acting and real-estate investments. (Left public domain, above courtesy Westernclippings. com.)

Will Rogers

Rogers was quite a celebrity in his heyday of the 1920s and 1930s as an American cowboy, actor, comedian, and social commentator. In the 1960s, his son Will Rogers Jr. attended NMMI, prompting many visits from his father to Roswell, as seen right in the snapshot taken by cadet Emmett D. White.

Sydney Redfield

Another popular Roswell painter, who like Peter Hurd loved to paint the nearby Hondo Valley, Redfield is shown below in 1968 painting a Hondo Valley still-life scene.

Elvis E. Fleming

Fleming was born in a dugout in Bailey County, Texas, and moved to Roswell with his wife Menza and two children in June 1969. He became an instructor of history at Eastern New Mexico University–Roswell. Before settling in Roswell, Fleming was a singer and guitarist who in the fall of 1953 moved to Fort Worth seeking a career as a musician. He won a talent contest on the *Big D Jamboree* and sang on many other stages and radio shows in the area. After graduating college, he started his teaching career in Morton, Texas. Many years later, when Fleming retired from ENMU-Roswell in 1997, he was the first Roswell campus retiree to be granted emeritus status by the ENMU Board of Regents. Later in life he became widely recognized as an award-winning historian and author. Below he is pictured with popular Roswell teacher Geri Byrd.

Paul Horgan

Horgan was born in Buffalo, New York, but moved to Albuquerque, New Mexico, at the age of 12. He attended the New Mexico Military Institute in Roswell where he eventually served as the school's librarian and also made friends with classmate Peter Hurd. Horgan wrote both fiction (usually set in the Southwest) and nonfiction. He won the Pulitzer Prize twice for his writings. The first was for *Great River: The Rio Grande in North American History* in 1955 and the second award was for *Lamy of Santa Fe* in 1976. His portrayal of the colonial Spanish and the Anglo-American pioneers' hardships in establishing settlements in the Southwest is considered the best ever written. Horgan went on to have 40 of his books published receiving many awards in the process. Horgan died in 1995.

Mine That Bird

Mine That Bird poses like a true celebrity for Roswell photographer Mark Wilson at his stable in Roswell below. It was a rainy day on May 2, 2009, and the track was very muddy in Louisville at the 135th Kentucky Derby. No one expected Mine That Bird to win; in fact, many expected him to come in last. After all, it was his first time in the race, as well as that of his trainers Chip and Bennie Wooley Jr. But, ridden by jockey Calvin Borel, Mine That Bird shot from last to first place when he finished 6 and 3/4ths lengths ahead of Pioneer of the Nile. All in all, "the Bird," as some people referred to him, completed 1¼ miles in 2:02.66 on the muddy track. Everyone in attendance was shocked and the Bird created one of the biggest upsets in Kentucky Derby history, making him an overnight star. During a brief stint in California after the race, he even had a 24-hour webcam installed in his stall. A true celebrity in every way, he now has a popular Facebook page, he was featured on the cover of *Sports Illustrated*, several books have been written about him, and there is even talk of making a film starring the underdog gelding champ. Mine That Bird returned to Roswell under police escort to his Double Eagle Ranch home, where he lives out a quiet retirement at the ripe old age of five. (Mark Wilson photograph.)

Susan Graham (RIGHT)

Graham was born in Roswell, New Mexico, on July 23, 1960, and raised in Midland, Texas. She is a graduate of Texas Tech University and the Manhattan School of Music. After studying piano for 13 years, she was a winner of the National Council Auditions, sponsored by the Metropolitan Opera. She also received the Schwabacher Award from the Merola Program of the San Francisco Opera. Graham made her international début as a mezzo-soprano at Covent Garden playing Massenet's *Cherubin* in 1994. Other notable performances include her portrayals of Jordan Baker in *The Great Gatsby*, Sister Helen Prejean in *Dead Man Walking,* and Sondra Fichley in *An American Tragedy*. A recording of her Carnegie Hall recital and debut was released in 2003. Graham also sang at George W. Bush's second inauguration in 2005 and performed at Sen. Edward M. Kennedy's funeral in 2009. (Dario Acosta photograph, courtesy Michael Lutz, 21C Media Group, Inc.)

Elmer "Skinny" Schooley

Schooley's artwork is represented in the Museum of Modern Art, the Brooklyn Museum, and every museum in New Mexico. His monumental series, "The Wilderness Series," spans three decades and over 100 paintings. He started the first lithography studio in Northern New Mexico. Schooley, born in Kansas in 1916, long desired to move out west but didn't come to New Mexico until 1947. (Courtesy Ted Schooley.)

Demi Moore

Right is Demi Moore when she was known as Demi Guynes, before she became famous. This photograph is from an old NMMI yearbook in which Demi appeared as one of the "NMMI Sweethearts," although she did not attend the school.

Bill and Walt Wiggins

Above are Bill Wiggins and his family, including his beloved wife Ruthelle and grandson Jeff. Behind him, left to right, are daughters Elaine, Sandra, and Kathy. Bill is a self-taught painter who began in 1940 and continues to paint today despite macular degeneration. In 2011 at the age of 93, Bill Wiggins won the Governor's Award for Excellence in the Arts. Left is a family vacation photograph of Walt Wiggins along with his wife Roynel. Also pictured are children Walton Jr., Kim, and Lisa. Kim Wiggins has since become a famous Roswell painter with an inimitable style of color and undulating landscapes. Walt was a photographer whose work appeared in *Sports Illustrated*, *Argosy*, *True*, *Look*, *Outdoor Life*, and *Sports Afield* to name just a few.

Clarence Siringo Adams

Adams was a much-loved historian in Roswell who used to publish *The Old Timer's Review*, a wealth of information regarding Southeastern New Mexico history. Clarence got his middle name from the famous Cowboy Detective, Charles Siringo, who stayed the night in the Adams home the night Clarence was born.

James D. Shinkle

Not to be confused with the former governor James F. Hinkle, James D. Shinkle was one of Roswell's first and best historians. For years, his book *Fifty Years of Roswell History* was the only book published on Roswell's history, and is still used as a reference today. Here he is shown as a basketball coach in Roswell.

CHAPTER FOUR

Hometown Heroes: Soldiers, Businessmen, and Philanthropists

Roswell is home to many heroes and has a strong history with the military, beginning with the men of Battery A who served in World War I and gave aid to Columbus, New Mexico, after Pancho Villa's notorious raid. Many of the students of NMMI have gone on to illustrious military careers, and many of the instructors there already had them before taking teaching positions. In the 1940s, Roswell Army Air Field was home to the elite military presence in the world, the 509th Bomb Unit. But not all of Roswell's heroes were part of the military. Most were ordinary men and women just trying to benefit their community.

A particularly interesting story about heroes in Roswell's past involves several of the Legendary Locals in this book working together. One day in 1936, there was a rumor that the First National Bank of Roswell, then under the presidency of James Hinkle, was to be robbed. As a precaution, Lou Fullen and Capt. Burt Mossman stationed themselves at the second floor of the bank ready for action. Across the street on the third floor of the Clarence Hinkle Building, Harry Thorne and Hiram M. Dow took vantage points with rifles in hand in case any robbers showed up. And lastly, the former governor and then bank president himself James Hinkle sat behind his desk with a 12-gauge double-barreled shotgun with a .30-06 Winchester repeating rifle close by for backup. However, no guns were fired that day. Cecil Bonney, who related this story in his book *Looking Over My Shoulder*, closed the story best by writing, "The reported bank robbers never came. Woe unto them if they had."

Amelia Bolton Church

Church was one of the most influential women of Roswell. She was born, however, in Wexford, Ireland, on July 3, 1862. She and her family moved to New Mexico when her father joined the US Army and was sent west to fight the Indians at Fort Stanton. It was in Lincoln where the family lived in the late 1870s that Amelia would witness many of the events of the famous Lincoln County War, including the shooting of Sheriff Brady by Billy the Kid. Amelia was married three times in her life, her first two husbands residents of Lincoln. In 1891, she married Joshua P. Church of Roswell and moved to the town where she would hold a great influence for the next 60 years. Her role as a civic leader began after her husband's death in 1917. Her notable achievements include restoring El Torreon, a historic structure in Lincoln, in the 1930s and also helping to establish the Roswell Museum and Art Center. Busts of Amelia Church along with Capt. J.C. Lea, John Chisum, and J.J. Hagerman were on display in the museum the day it opened on October 6, 1937. Church died at 94 on March 22, 1957.

Hiram and Ella Lea Dow

Hiram Dow served in New Mexico for 50 years as one of the state's most outstanding civil and criminal lawyers and for a time he was the state's lieutenant governor. Dow came to Roswell to attend NMMI, where he was regarded as a good student, aside from the time he stuck a dummy in his bed and snuck out. He graduated in 1905 and from there went to law school, where he graduated with honors. When he returned to Roswell, he married Ella Lea, the daughter of Captain Lea. Like his late father-in-law, Dow also served as mayor of Roswell. Dow died on March 7, 1969. His wife Ella preceded him in death in 1962. The two can be seen together right, next to a bust of Captain Lea at the Roswell Museum and Art Center.

INSTRUCTORS & STUDENTS G.M.I. ROSWELL N.M.

Robert Goss and New Mexico Military Institute

The coming of New Mexico Military Institute to Roswell began with Col. Robert Goss, who came to Roswell upon the insistence of Captain Lea. Lea felt a military school would be good for the town, and his rowdy and aptly named son Wildy. Above can be seen Goss and cadets reclining outside Goss Military Institute, and below is the school under construction. Eventually Goss left Roswell, but the school remained and was eventually rebuilt and named the New Mexico Military Institute, still a staple of Roswell to this day. From 1891 to 1894, it was located at 5th and Main Street, then moved to the 700 N. Block of Main Street in 1895. From the fall of 1898 to the present, it has been located on North Hill.

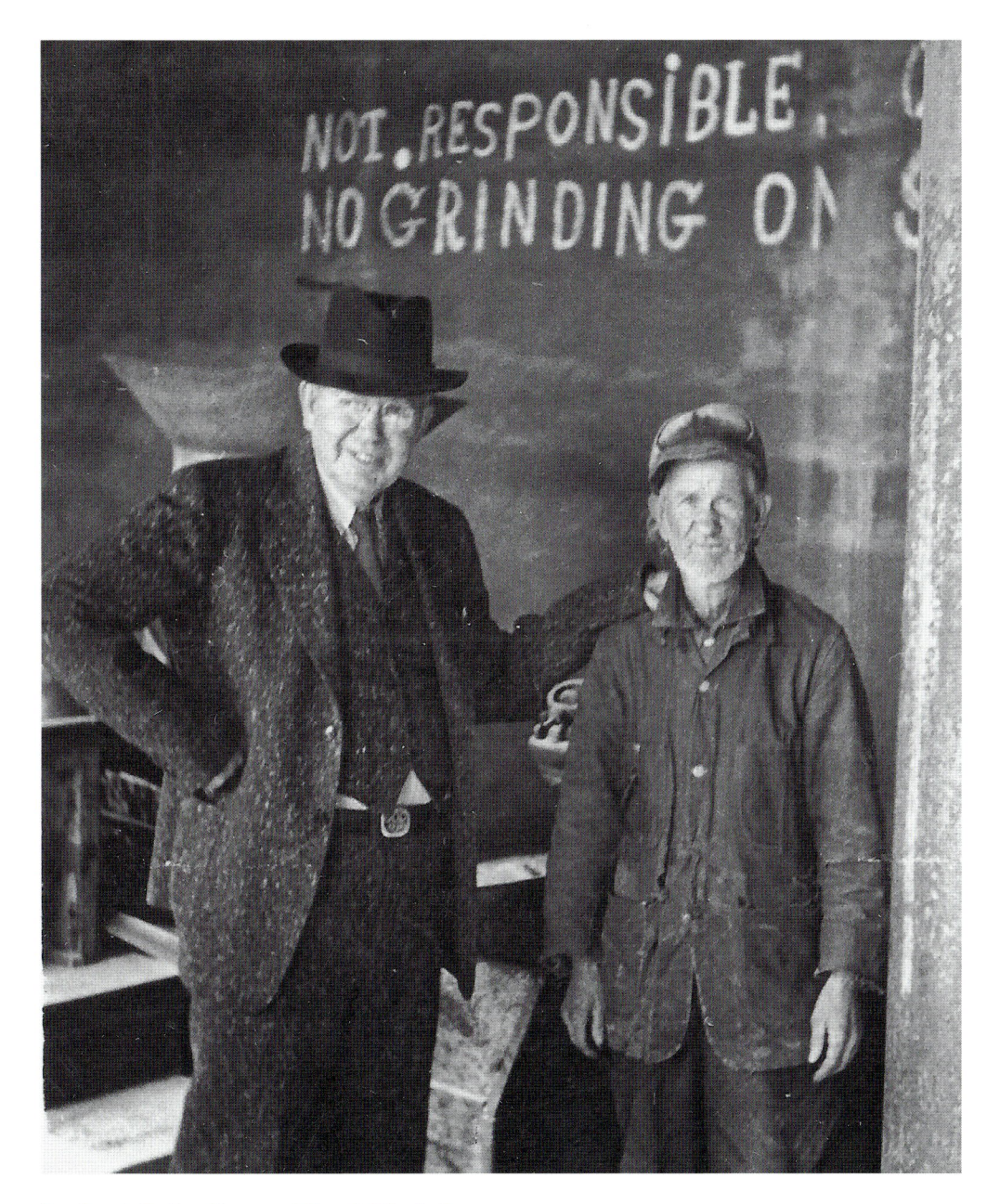

Dr. Louis B. Boellner and Frank Blashek

The two men above, Dr. Louis B. Boellner (left) and Frank Blashek (right), both hold interesting histories in Roswell. Frank Blashek's father, George, came to Roswell and started Blashek's Mill (where the above photograph was taken) in 1893, which produced flour and meal up until World War II. Dr. Boellner had many interesting accomplishments in his lifetime. He was nationally recognized as a horticulturist and the two plants he created by crossbreeding: Kwik-Krop black walnut and scented dahlia. Boellner was primarily an optometrist in Roswell, but he had many adventures, including fending off rattlesnakes with a .22 when he was trapped in a sinkhole outside of Roswell, as well as his trip in an old Studebaker EMF car from Roswell to Kansas and back, just to name a few.

Roswell Battery
New Mexico Nat'l Guard
arriving at Columbus.

W.H.Horne
Co
El Paso Tex.

Battery A

Roswell's regiment of servicemen in World War I, Battery A, consisted of 296 men, 235 of whom saw action in the war. During the war, they lost only two of their members, and only 12 in total were wounded. The two photographs on this page show Battery A when they gave aid to Columbus, New Mexico, after the famous raid of Pancho Villa in March of 1916.

Lt. Col. Charles M. DeBremond

DeBremond was born in Switzerland in 1863, where he began his military career eventually becoming a captain in the Swiss Army. He arrived in New Mexico in 1891 and eventually came to Roswell where he served in Battery A. DeBremond fought in World War I in France, rising to the rank of major, and participated in such battles as the Battle of Chateau-Thierry. DeBremond was called back to the States to train a regiment of men in New York in 1918, the same year he returned to Roswell as a lieutenant colonel. DeBremond died in Roswell in 1919 with physicians of the time believing it was a result of German gas he was exposed to during World War I. In the below image, Colonel DeBremond is shown (left) with his aid in Columbus, New Mexico, after the raid of Pancho Villa.

Robert Orville Anderson

Anderson (often referred to as "Robert O.") was born in Chicago on April 13, 1917, to the Swedish immigrants, Hugo A. Anderson and Hilda Nelson. His father was a well-known banker. Anderson became a businessman, landowner, rancher, philanthropist, and wildcatter. While attending the University of Chicago, he worked on pipelines in Texas during his summer breaks. After graduating, he worked for the American Mineral Spirits Company, a subsidiary of Pure Oil. In 1941, he and his brothers bought a refinery in New Mexico. He later founded Atlantic Richfield Oil Co. and was Arco's chairman for two decades. Arco became the sixth-largest oil company in the United States. By 1950, Anderson owned many refineries; he had built pipelines, and had become a true wildcatter. In 1967, along with others, he was responsible for the discovery of the largest oil field ever found in North America at Prudhoe Bay, Alaska. Prudhoe Bay accounts for one fifth of US oil production and has produced billions of barrels of crude oil. In 1986, he was the largest individual landowner in the United States, with ranches in Texas and New Mexico amounting to some 2,000 square miles. Anderson passed away on December 2, 2007.

Robert O. Anderson and Family

Above is the Robert O. Anderson family c. 1957 consisting of, left to right standing, Robert Bruce, Robert O., left to right sitting, Kit, Julie, Beverly, Barbie, Phelps, and wife Barbara. Robert O. also has a well-known brother Donald Anderson who lives in Roswell and is still heavily active in the community. When Robert O. Anderson lived on the Diamond A Ranch in the Hondo Valley, since there were no nice restaurants nearby that he could take his company to, he decided to build one by adding a porch, a large tower, and a pavilion onto the old mercantile in Tinnie for a cost of several hundred thousand dollars. It can be seen in the ad below.

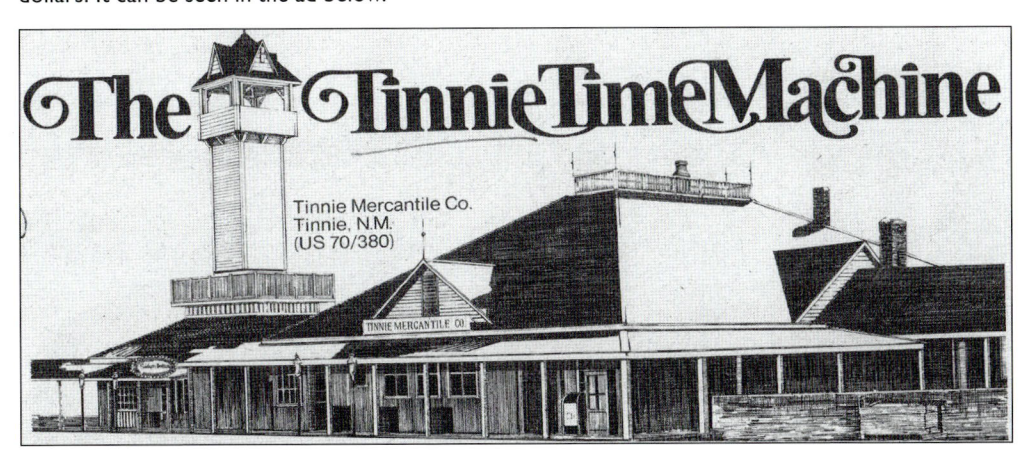

The Tinnie Time Machine

Tinnie Mercantile Co.
Tinnie, N.M.
(US 70/380)

Joseph Richard "Joe" Skeen

Skeen was born in Roswell on June 30, 1927. As a teenager, his family moved to Seattle, Washington. Skeen joined the US Navy toward the end of World War II. When he came back home, he became a graduate of Texas A&M University. After several years of owning a ranch in nearby Hondo Valley, Skeen was elected to the New Mexico State Senate as a Republican in 1960. In 1970, he ran for lieutenant governor on an unsuccessful ticket headed by future senator Pete Domenici. As a conservative Republican congressman from southern New Mexico, Joe Skeen served for 11 terms in the US House of Representatives between 1980 and 2003. The administration building at the Bitter Lake National Wildlife Refuge is named in his honor, as well as the County Building in Chaves County. Skeen passed away on December 7, 2003.

Poe Corn

Corn, shown left in his 1955 NMMI yearbook photograph, was an outstanding athlete and military man. He was called "the Cowboy Quarterback" at NMMI, and he had a 23-year career in the Army. Today, Roswell has a popular Poe Corn basketball tournament every year. Corn won numerous awards as an athlete, coach, and military man and is still fondly remembered in Roswell.

Norman Eugene Brinker

Brinker was a prominent restaurateur who oversaw Burger King, Haägen-Dazs, and invented Chili's, which he started in Roswell, his hometown. He was responsible for the addition of many new business ideas such as the salad bar. He died from pneumonia during a vacation in Colorado in 2009. (Drawing by Neil Riebe.)

Sam Donaldson

Known for being a TV reporter and news anchor for ABC News, Donaldson was born in El Paso, Texas, on March 11, 1934. He grew up in a small farming family in Chamberino, New Mexico. He attended New Mexico Military Institute in Roswell and the University of Texas at El Paso. While attending school in El Paso, he was the station manager of KTEP, the campus radio station. He later joined the US Army and served as an artillery officer. Donaldson began his career at ABC as a Washington correspondent in October of 1967 and eventually moved up to anchoring the network's 11:00 p.m. Saturday and Sunday newscasts. Notably, he was the chief correspondent for ABC covering the Watergate House Judiciary Committee hearings in 1973 and 1974. Donaldson's career continued to escalate as he became anchor or co-anchor of many notable programs including the *ABC Sunday Evening News* and *Prime Time Live*. Now retired, he resides on his ranch near Hondo, New Mexico. In the image above, he is in Roswell during a visit from then-president Ronald Reagan.

Minor Huffman

Huffman was a part of many organizations in Roswell, including involvement in founding the Historical Society for Southeast New Mexico, but he is perhaps best known as the first Boy Scout Executive for Eastern New Mexico. Here he is shown with John Glenn and a group of boy scouts who helped Glenn make a TV spot for the BSA in 1959 in Miami, Florida.

Lake Frazier

Frazier was a well-known mayor of Roswell in the 1960s, a time in which he also ran for governor of the state. Northeast of Roswell there exists the ruins of an old schoolhouse, one of the area's only "ghost towns." The area is now called Frazier because Lake was the one who made it possible for the school to be built.

Hial and Warren Cobean

Hial Cobean, above left, and brother Warren, were the owners of Cobean Stationery Co., for a time the oldest continuously operating bookstore in New Mexico. Hial Cobean came to New Mexico in 1890 and attended NMMI. Hial and Warren opened Cobean Stationery Co. in 1916. Earlier in his career Hial worked for the Hagerman Offices at South Springs as well as Joyce Pruitt Co

Stu Prichard

Prichard is well known in Roswell as a historical writer, and as the man to first bring McDonald's to Roswell and the John Chisum statue to Pioneer Plaza. Prichard also had an illustrious military career, fighting in World War II and continuing his service until Walker Air Force Base closed in Roswell in 1967. He is the man at the far left above.

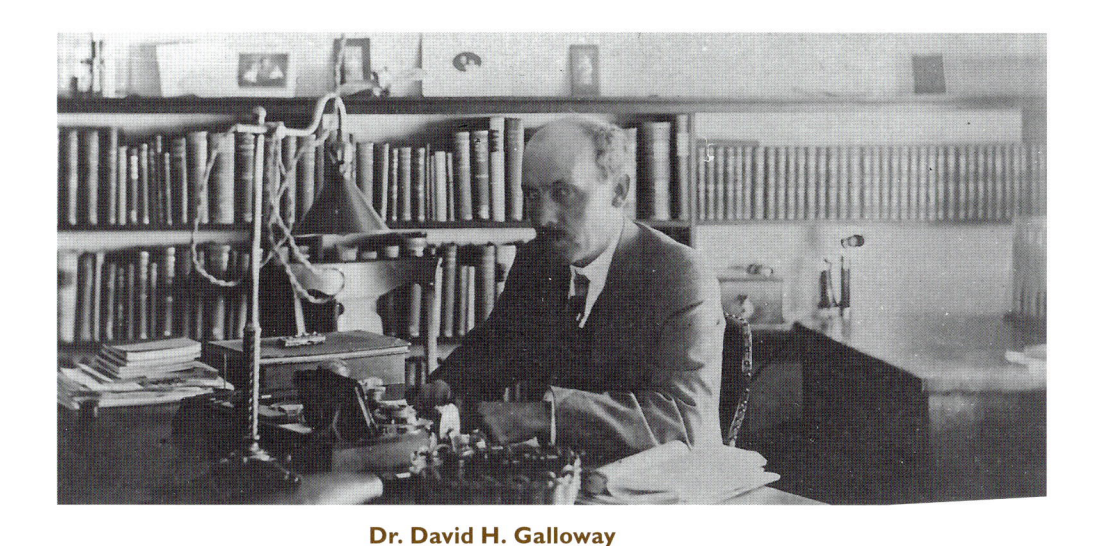

Dr. David H. Galloway

Galloway, pictured above in his office, was one of Roswell's first surgeons and one of the town's best-remembered physicians. He was so careful about making emergency house calls that he had two cars, one just in case the other wouldn't start! He was also a popular speaker around town and was greatly missed after he passed away in 1944.

Roy Norton

Below in his biplane is Roy Norton, who owned the well-known Norton Hotel in Roswell. Norton purchased the Gilkeson Hotel in 1943, which he renamed in his honor. The hotel operated until 1966.

Ben Ginsberg

Another mainstay of Roswell's Main Street over the many years has been Ginsberg Music Co. Above is Ben Ginsberg (far left) outside of his store along with (left to right) Bessie Sherman, Porter Rogers, Mary Garcia, Tom Rogers, and Mrs. Tom Rogers c.1937 during the Eastern New Mexico State Fair.

Don Bullock

Bullock's Jewelry began in Roswell thanks to O.L. Bullock, and continued under the management of his son Dixon. When Dixon Bullock died in 1976, his 17-year-old son Don took over the business while he was still in high school. The change was a closely guarded secret and young Don "aged" himself with a beard and three-piece suits, as seen in the left photograph.

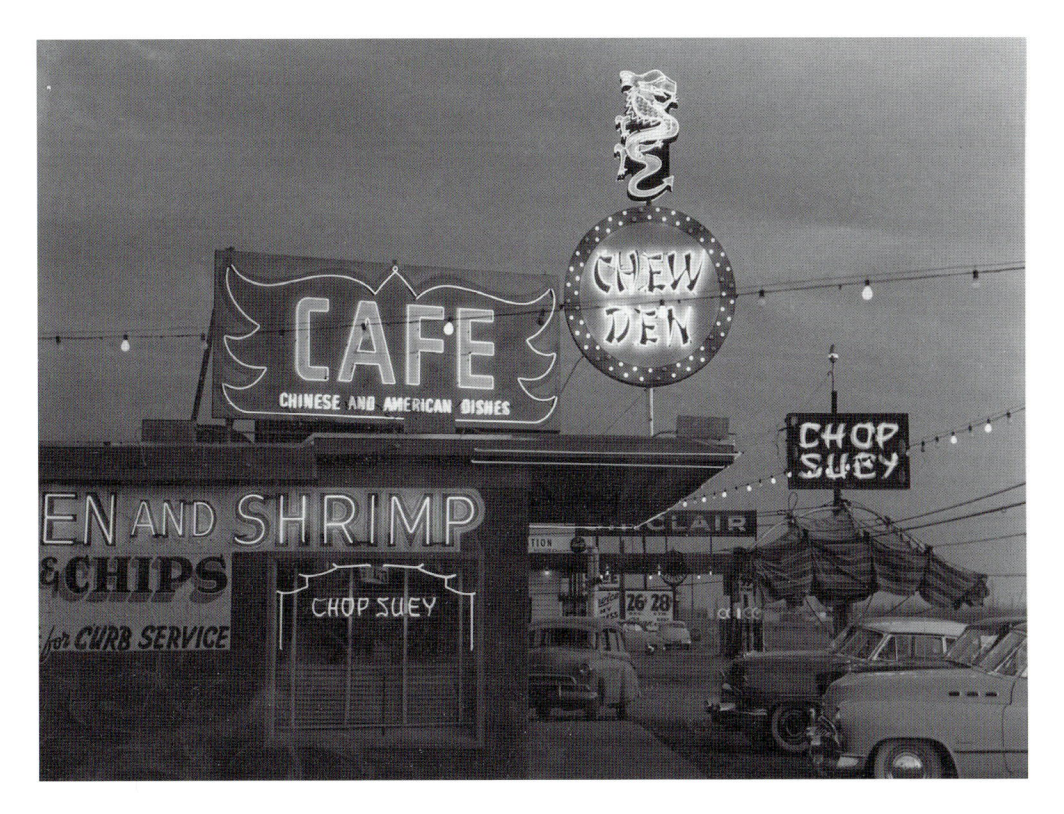

Jack and Suzie Chew

Jack and Suzie Chew met in China where their families arranged their marriage in 1947. Jack, who had already been living in the States, served as a tail gunner in a B-17 bomber during World War II and also spent 21 months as a POW in Germany when his plane was shot down. Jack and Suzie are well known in Roswell for their Chinese restaurants such as Chew Den and Chew's West.

Bob Chewning

For many years, Chewning Footwear was Roswell's premier shoe store until it closed recently in 2011. The Chewning family has deep roots in Roswell, arriving here before the 20th century dawned. Bob Chewning, in his beloved store, is shown right.

Dorothy Cave

Cave, along with the likes of David Clary and Elvis Fleming, is another of Roswell's many modern-day talented authors and historians. Her more famous works include *Beyond Glory* and *God's Warrior: Father Albert Braun, O.F.M., Last of the Frontier Priests*. She is also the winner of two Southwest Writers Awards, the Simon Scanlon Award, and the International Literary Award.

Ernestine Chesser Williams

Williams was a beloved Roswell author, volunteer, and historian with deep family roots in the area. Her family first came here in 1909 and Ernestine was born in 1913, the third of 10 children. All of the Chesser children remained in Roswell where they were born and their descendants are still part of the town.

Judy Armstrong
The Eastern New Mexico University in Roswell has had many wonderful provosts over the years, one of its most influential being Dr. Judy Armstrong. Under her guidance, attendance reached an all-time high in 2005, surpassing the 4,000 mark. She was also instrumental in partnering the campus with other institutions such as NMMI, NM Youth Challenge, and the International Law Enforcement Academy. (Courtesy ENMU-R.)

Betty Sims Solt
Solt is a member of the National Cowgirl Hall of Fame, being inducted in 1990. She participated in some of the very first national high school and college rodeos. In 1957 and 1958, she won the NIRA Barrel Racing titles as well as All Around Cowgirl and National Queen attendant in 1957. In addition to running a cattle ranch, Solt is also a poet and historian.

Morgan Nelson

Nelson, left, was born in 1919 in Cottonwood, New Mexico, and moved to East Grand Plains (a farming community near Roswell) in 1924 and has lived in his current home in East Grand Plains since 1928. Nelson left the Roswell area in 1941 for a stint in the Air Force and returned home in 1945. He stayed in the Air Force Reserve until 1967, serving in the Middle East and European theaters during World War II. He was released from duty in 1946. Nelson was then recalled for the Korean Conflict in 1953–1954. He married Joyce Laseur in 1950 and remained married for 58 years until her death in 2008. In addition to managing his family's farm, Nelson became interested in politics and in 1948 was elected to the New Mexico State Legislature as a representative. Nelson served two years before losing the next election. He was re-elected for four more terms until 1961. Nelson is known as one of the utmost authorities on the water situation of New Mexico. He serves on the board of the New Mexico Farm and Ranch Heritage Museum as well as serving the Historical Society for Southeast New Mexico for many years in many capacities. He still remains heavily active in the Roswell community.

Harry Thorne

Thorne was described by Cecil Bonney as a "big, jovial, long legged sheriff" and "one of the most efficient peace officers the county ever had." Thorne served as sheriff of Chaves County from 1929 to 1931, but he was first made an officer of the peace back in 1897. Thorne continued to be a deputy up until 1953, possibly making him the longest-serving peace officer in New Mexico for a time. Thorne had a passion for baseball, and after World War I he managed a semi-pro baseball team in Roswell, which is why the below location is named Thorne Park.

Jack Swickard

Swickard, second from right above, is a decorated Vietnam veteran who calls Roswell home. During the Vietnam War, Swickard was a helicopter pilot who flew many rescue missions and as a result was the recipient of two Distinguished Flying Crosses, the Bronze Star Medal, 23 Air Medals, the Army Commendation Medal, and the Vietnam Cross of Gallantry with Palm. After his service, Swickard returned to Albuquerque in 1969 where he was editor of the *Albuquerque Tribune*. In 1974, he came to Roswell as editor of the *Roswell Daily Record*. Swickard has held numerous other positions over the years including being president of the NM Press Association and a member of the Supreme Court Committee on Judicial Elections. Left, Swickard is shown on his third trip back to Vietnam since the war; he is standing behind a desk in the Vietnamese royal residence known as the Citadel. (Both courtesy JackSwickard. Blogspot.com.)

John "Cactus Jack" Anderson

Anderson, left, is both a war hero and a locally famous TV personality. He is a surviving veteran of the attack on Pearl Harbor on December 7, 1941. Anderson was stationed on the doomed USS *Arizona* of which only a handful of the crew survived. During the attack Anderson, who was supposed to be part of a gunner turret below, reasoned that he would be better utilized at the anti-aircraft gunner station on the boat deck where his twin brother was stationed. As he climbed the ladder to get to the boat deck, a huge explosion occurred that killed 1,177 of the ships 1,400 crewmen. John survived the explosion and in the process managed to save the life of another man who was on fire. When a rescue boat came along, Anderson refused to leave without his brother and ended up being shoved into the boat with a wounded man in his arms. Anderson later returned to the *Arizona* that day on another boat he commandeered with another man, rescuing another three men from the ship. Unfortunately, the rescue boat was struck by an explosive shell and Anderson was the only survivor. He swam back to shore amidst gunfire and oil fires on the water. On shore, he managed to find a rifle, which he took cover with ready to keep fighting the Japanese. Anderson never did see his brother again; he died on the *Arizona*. Space doesn't permit the telling of Anderson's many other adventures in World War II, but he later became a well-loved weatherman and TV personality in Roswell called "Cactus Jack," and is especially fondly remembered by baby boomers. Once during his TV career, he met Elvis Presley, who walked into the KSWS TV station in Roswell in the 1950s. Anderson still calls Roswell home today and often returns to Pearl Harbor.

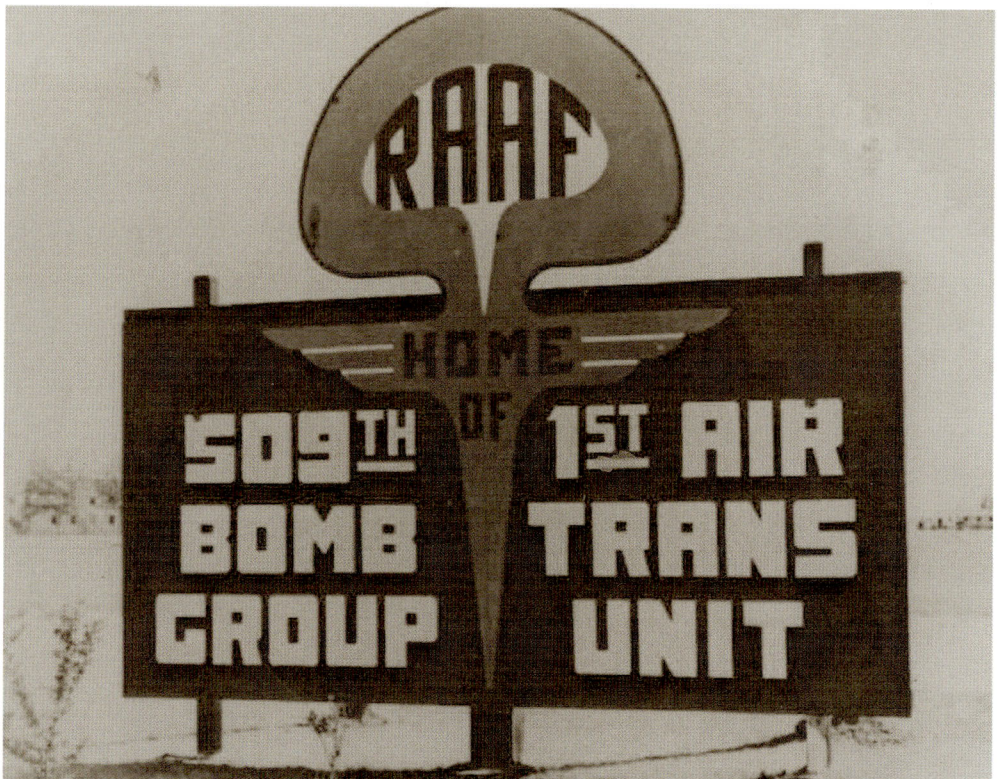

The 509th Bomb Squadron and the *Enola Gay*

The *Enola Gay*, above in Roswell, and her crew which dropped the atomic bomb on Hiroshima in Japan came to Roswell after World War II ended, along with the 509th Bomb Unit, in November of 1945. The *Enola Gay*'s time at the Roswell Army Air Field was brief, because it was eventually decided that due to the aircraft's role in history it should be retired to a museum. The 509th Bomb Unit was the elite US military presence in the world at the time, the world's only atomic bomb unit.

Col. William H. "Butch" Blanchard

Blanchard was a very popular base commander of the Roswell Army Air Field in the late 1940s during the time the 509th was stationed there. He was born in Boston, Massachusetts, in 1916 and began his military career at West Point, graduating from there in 1938. He held many positions during World War II and flew the first B-29 into China in preparation for the bombing of Japan in 1944. Eventually, he became commander of the 509th, and came to Roswell in 1945. Later on Blanchard became a major general in 1957 assuming command of the SAC's Seventh Air Division in England. He died of a heart attack at the Pentagon in 1966 at the rank of general and Vice Chief of Staff of the Air Force.

Maj. Jesse Marcel

Marcel is best known perhaps for this famous photograph, printed in newspapers across the nation in 1947 during what is now called the Roswell Incident. Marcel was already a very accomplished officer in the military before the events of Roswell who had served as head of security and intelligence briefings at Kwajelein Base in the Pacific, and held a diploma from the Army Air Forces Training Command in radar technology and three major commendations from the military. In 1947, Marcel was stationed at the Roswell Army Air Field as the main intelligence officer for the 509th Bomb Group. The story of the Roswell Incident, in a saucer-shell, is this: On a stormy July 1947 night, an object exploded over the J.B. Foster Ranch in Corona, of which Mack Brazel was foreman, leaving a trail of debris. The rest of the craft, whatever it was, impacted 35 miles north of Roswell. After a few days puzzling over the debris, Brazel took it to the big city of Roswell, where eventually he was connected to Marcel who accompanied Brazel back to the ranch to collect samples. Marcel famously showed some of these samples to his wife and son later. The above photograph was taken on July 8, 1947, when Jesse was flown to Carswell Air Force Base in Fort Worth and used in the alleged cover-up, which is why he poses here with "staged" weather-balloon debris rather than the real debris he later claimed to have brought with him. It was Marcel's opinion that the real debris was "not of this earth." After July 9, 1947, talk of the crashed flying saucer cooled down and was for the most part forgotten all the way up until the 1970s, when Marcel, then living in Baton Rouge, Louisiana, was introduced to famous UFO researcher Stanton Friedman. And the rest as they say, is history. . . .(Courtesy *Fort Worth Star-Telegram* Collection, Special Collections, the University of Texas at Arlington.)

Walter Haut

Haut is best known for his involvement in the 1947 Roswell UFO Incident and also as one of the founders of the wildly successful International UFO Museum and Research Center. Haut was also heavily involved in civic affairs in Roswell. He is the man standing at left above at a city function. The man sitting to his left is Hial Cobean.

Jesse Marcel Jr. MD

Marcel is best known as a witness to the strange "UFO debris" in 1947 Roswell thanks to his father, Major Marcel. Marcel Jr. has served in both the US Navy and the Army National Guard. Recently in 2004 he served as a flight surgeon in a helicopter unit in the Iraq war for 13 months. Marcel, above, was in his late 60s at the time. (Courtesy Noe Torres.)

Edgar Mitchell (LEFT)

Aliens aren't the only space travelers to have lived in Roswell at one time or another. Mitchell, the sixth man to walk on the moon, also briefly lived in Roswell and grew up in the nearby town of Artesia where he graduated high school. In 1953, Mitchell joined the Navy where he soon began training as a pilot. This eventually led to him being recruited by NASA to be an astronaut in 1966. On January 31, 1971, Mitchell as lunar module pilot, along with commander Alan Shepard and command module pilot Stuart Roosa, headed for the moon as part of the Apollo 14 mission. They landed on the moon February 5, 1971, touching down on the Fra Mauro Highlands region of the moon, the original destination of the ill-fated Apollo 13 mission. Much information was collected on this mission, but more memorable for most was when Shepard hit a few golf balls on the lunar surface with a club he brought along from earth. After his trip to the moon, Mitchell retired from NASA in 1972 and was awarded various medals and doctorates. Thanks to his time spent in Roswell, Mitchell is also an avid UFO believer and says after his NASA career several Roswell residents confided in him what they knew about the crash. Mitchell currently lives in Florida. (NASA photograph courtesy Noe Torres.)

Judge Bobby Ray Baldock and Tim Jennings

Baldock, above left, is a federal judge and off and on Roswellian. He came here with his parents in 1946 and graduated from NMMI in 1956. He held a private practice and also taught courses at ENMU-R from the early 1960s to the early 1980s. In 1983, he was nominated by President Reagan to be a federal judge. He currently serves as chairperson of the Committee on Financial Disclosure. Jennings, above right, was born on September 4, 1950 in Roswell along with a twin brother. He got into politics in 1975 when he was elected to the Chaves County Commission. Jennings was first elected to the New Mexico State Senate in 1979 where he still serves today. He served as Democratic whip from 1985 to 1987, majority whip from 1989 to 1996, and majority floor leader from 1997 to 2001.

Staff Sgt. Scott Lilley
Lilley joined the Air Force in October of 1999 and continued to serve in the military up until he retired in 2010, despite a traumatic brain injury (TBI) he suffered in Iraq. It was April 15, 2007, in Iraq when Lilley was working as part of a police transition team and a roadside bomb detonated next to the humvee he was riding in. The humvee was one of five vehicles returning to base after a training exercise when it was attacked. Lilley was struck in the head by shrapnel and was severely injured, though he continued to man his turret gun in defense against enemy gunfire and even a rocket-propelled grenade. Lilley was pulled from his turret by the squad medic, and doctors later said it was remarkable he was able to stay conscious and keep fighting for as long as he did. After having cranioplasty surgery at Balad Air Base, Lilley was flown back to the States where he eventually made a miraculous recovery. Though at first he could barely speak let alone walk, he surprised his doctors by getting out of bed and sitting in a chair. During his recovery, Lilley would become both a national and a hometown hero, even meeting President George W. Bush, who took a special liking to him. Lilley would see President Bush again four more times and was invited to the president's Farewell Address. Less than two years after the accident, Lilley returned to active duty as a security force training instructor at Lackland Air Force Base and retired on December 23, 2010. (Courtesy Frank and Jolene Lilly.)

Chaves County Heroes Memorial

The Fallen Heroes Memorial located at the Roswell Civic and Visitors Center was dedicated July 4, 2003, to those who fell in the line of duty. Among those listed are William Rainbolt, Roy Woofter, Rufus Dunnahoo, Barney F. Leonard, Amos A. Harbert, Henry S. Vail, Fred Van Winkle, Joe Montoya Salas, John Howard Vincent, Robert E. Evans, Gary L. Lambert, Ramon Robert Solis, Damon Kyle Talbott, Steve Lovato, Steven Louis Jones, and Charles Brian Miller. Recent fallen heroes of Roswell include PFC Antonio Stiggins, PFC Ricky Salas Jr., Sgt. Andrew Perkins, Sgt. Christopher Sanders, Sgt. Tommy Gray, Spec. Brynn Naylor, LCpl. Steven Chaves, Sgt. Moses D. Rocha, and P.O. 2nd Class Meneiek M. Brown. A memorial for all fallen soldiers from Roswell stands in front of the Chaves County Administrative Center, and another monument has recently been erected outside the Chaves County Courthouse.

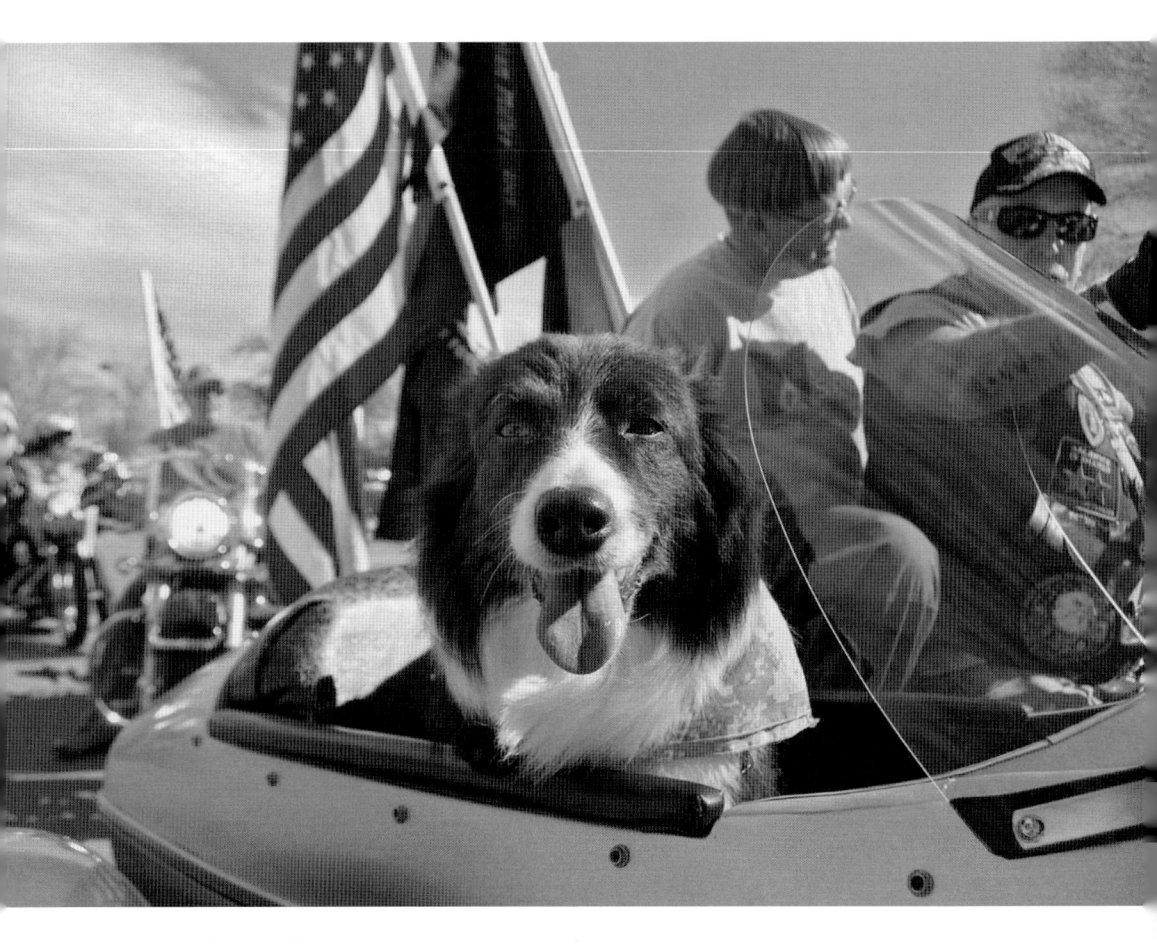

Sage the Service Dog

Sage the Service Dog is New Mexico's last surviving search and rescue dog who served in active duty on September 11, 2001, searching for victims at the Pentagon. A few years after serving at the Pentagon, Sage also served in the Gulf Coast in the aftermath of hurricanes Katrina and Rita. Sage also did several tours of duty in Iraq. Sage, who also battled cancer likely as a result of lethal substances she was exposed to in Iraq, now resides in Roswell with her owner Diane Whetsel. Sage has even inspired her own foundation: the Sage Foundation for Dogs Who Serve. The foundation helps give funds to dogs that need medical treatment due to service for their country. Happily, 12-year-old Sage is cancer free after recent chemotherapy. In 2011, she competed in the Hero Dog Award competition for the American Humane Association. Although she did not win, for a time she ranked third in the competition. (Mark Wilson Photograph.)

BIBLIOGRAPHY

Bonney, Cecil. *Looking Over My Shoulder: Seventy-five Years in the Pecos Valley*. Roswell, NM: Self-published, 1971.

Burnett, Roger. "People of Interest in the Roswell Area." Roswell, NM: Historical Society for Southeast New Mexico, 2007.

Fleming, Elvis E., ed. *Roundup on the Pecos II*. Lincoln, NE. iUniverse, Inc., 2005.

Fleming, Elvis E. *Treasures of History IV: Historical Events of Chaves County, New Mexico*. Lincoln, NE. iUniverse, Inc., 2003.

Fleming, Elvis E. and Ernestine Chesser Williams. *Treasures of History II: Chaves County Vignettes*. Roswell, NM: Historical Society for Southeast New Mexico, 1991.

———*Treasures of History III: Southeast New Mexico People, Places, and Events*. Roswell, NM: Historical Society for Southeast New Mexico, 1995.

Layden, Tim. "One Reaction to Mine That Bird's Kentucky Derby Win? Complete Shock." SportsIllustrated.com: May 5, 2009.

LeMay, John. *Images of America: Roswell*. Charleston, SC: Arcadia Publishing, 2008.

——— *Images of America: Chaves County*. Charleston, SC: Arcadia Publishing, 2009.

——— *Images of America: Towns of Lincoln County*. Charleston, SC: Arcadia Publishing, 2010.

Mullin, Robert N., ed. *Maurice G. Fulton's History of the Lincoln County War*. Tucson, AZ: University of Arizona Press, 1968.

Palmer, Jessica. "Search Dog Up for Hero Award." *Las Cruces Sun News*. July 8, 2011.

Randle, Kevin. *The Roswell Encyclopedia*. New York: Harper Collins, 2000.

Shinkle, James D. *Reminiscences of Roswell Pioneers*. Roswell, NM: Self-published, 1966.

———*Fifty Years of Roswell History: 1867–1917*. Roswell, NM: Self-published, 1964.

INDEX

LEGENDARY LOCALS

AN IMPRINT OF ARCADIA PUBLISHING

Find more books like this at
www.legendarylocals.com

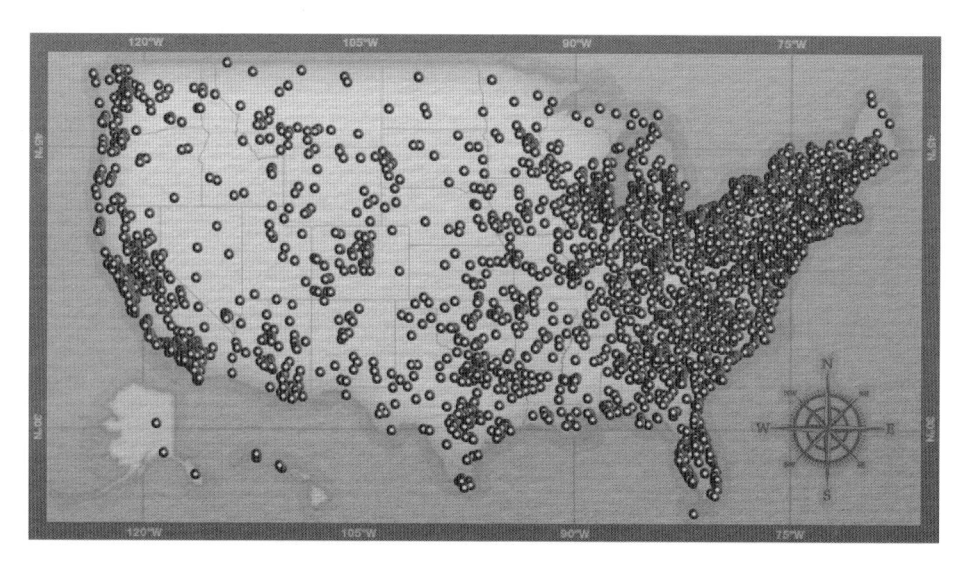

Discover more local and regional history books at
www.arcadiapublishing.com